Capturing Light in Watercolor

M. Simandle ©

Capturing
Light
in Watercolor

Marilyn Simandle
with
Lewis Barrett Lehrman

NORTH LIGHT BOOKS
Cincinnati, Ohio

SIERRA BIRCH, 20" x 16"

ABOUT THE AUTHORS

Marilyn Simandle

Watercolorist Marilyn Simandle resides in Santa Ynez, California, where she shares a light-filled home and studio with her husband, popular oil painter Ted Goerschner. Marilyn has devoted her efforts to watercolor for well over thirty years, and her work is readily recognizable for its brightness, vigor and distinctive style. A signature member of The American Watercolor Society, Marilyn's work is featured at Zantman Galleries of Carmel, CA; Cody Gallery in Santa Ynez, CA; and Shriver Gallery in Taos, NM. Her paintings are published as prints by Art In Motion, Vancouver, Canada.

Lewis Barrett Lehrman

Lew Lehrman is a professional watercolorist, teacher and author, whose books *Being An Artist* (1992), *Energize Your Paintings With Color* (1993), *Freshen Your Paintings With New Ideas* (1994), and *Oil Painting, The Workshop Experience* (1995) are published by North Light Books. He lives with his wife Lola in Scottsdale, AZ.

Lehrman comes to fine art following three decades in commercial art and illustration. He received his education at Carnegie Institute of Technology in Pittsburgh, PA; at Pratt Institute in Brooklyn, NY; and through numerous workshops and classes. A continuing watercolor instructor at The Scottsdale Artists' School and elsewhere, his work is on exhibit at Vanier & Roberts Fine Arts in Scottsdale, AZ, and at galleries in Connecticut and Minnesota.

Capturing Light in Watercolor. Copyright © 1997 by Marilyn Simandle and Lewis Barrett Lehrman. Printed and bound in Hong Kong. All rights reserved. No part of this book may be reproduced in any form or by any electronic or mechanical means including information storage and retrieval systems without permission in writing from the publisher, except by a reviewer, who may quote brief passages in a review. Published by North Light Books, an imprint of F&W Publications, Inc., 1507 Dana Avenue, Cincinnati, Ohio 45207. (800) 289-0963. First edition.

Other fine North Light Books are available from your local bookstore, art supply store or direct from the publisher.

01 00 99 98 97 5 4 3 2 1

Library of Congress Cataloging-in-Publication Data

Simandle, Marilyn.
 Capturing light in watercolor / Marilyn Simandle with Lewis Barrett Lehrman
 p. cm.
 Includes index.
 ISBN 0-89134-709-7 (alk. paper)
 1. Watercolor painting--Technique. 2. Light in art
I. Lehrman, Lewis Barrett. II. Title
ND2420.S584 1997
751.42'2--dc20 96-32193
 CIP

Edited by Pamela Seyring
Designed by Angela Lennert Wilcox

North Light Books are available for sales promotions, premiums and fund-raising use. Special editions or book excerpts can also be created to specification. For details, contact: Special Sales Manager, F&W Publications, 1507 Dana Avenue, Cincinnati, Ohio 45207.

METRIC CONVERSION CHART		
TO CONVERT	**TO**	**MULTIPLY BY**
Inches	Centimeters	2.54
Centimeters	Inches	0.4
Feet	Centimeters	30.5
Centimeters	Feet	0.03
Yards	Meters	0.9
Meters	Yards	1.1
Sq. Inches	Sq. Centimeters	6.45
Sq. Centimeters	Sq. Inches	0.16
Sq. Feet	Sq. Meters	0.09
Sq. Meters	Sq. Feet	10.8
Sq. Yards	Sq. Meters	0.8
Sq. Meters	Sq. Yards	1.2
Pounds	Kilograms	0.45
Kilograms	Pounds	2.2
Ounces	Grams	28.4
Grams	Ounces	0.04

DEDICATION

To my mother, who created the artistic environment in which I could grow, and who taught me the discipline to carry it out. To my wonderful, loving husband Ted, for his support and inspiration over the years. To all the wonderful students with whom I've worked; they have taught me all I know.

ACKNOWLEDGMENTS

First and foremost, I would like to acknowledge the year-long labors of Lew Lehrman who videotaped my demos; photographed my paintings; transcribed and clarified my thoughts; edited my words; and assembled the outpouring of material that has become this book. His conscientious efforts made the job nearly effortless for me.

My thanks to the staff and students at The Scottsdale Artists' School, who so patiently allowed us to videotape and photograph many of the painting demonstrations that appear in this book.

Lew and I both wish to acknowledge the efforts of our editors, Rachel R. Wolf and Pamela Seyring, as well as the designers and staff at North Light Books, who helped shape the volume you're about to enjoy.

—*Marilyn Simandle*

TABLE OF CONTENTS

PART TWO

Carve Out Lights in the Open Air

PART THREE

Paint Indoors With Light and Color

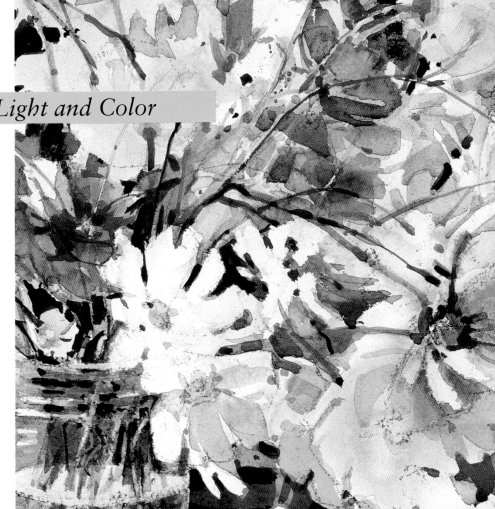

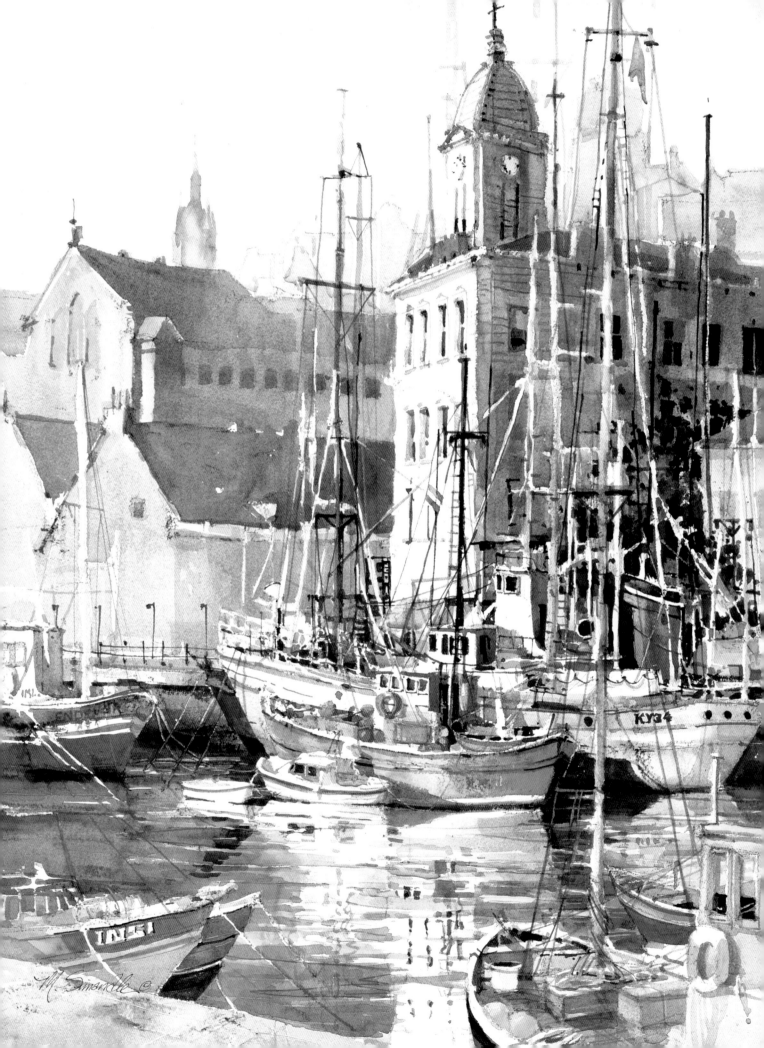

PREFACE

Even in 1990, before I began working on *Becoming a Successful Artist* (previously titled *Being an Artist*, North Light Books, 1992), I knew Marilyn Simandle through her work. A watercolorist myself, I had long admired her distinctive, light-filled style; at the earliest opportunity, I signed up for her workshop at The Scottsdale Artists' School.

It was a trip! Here was a watercolorist as full of creative energy as her paintings. The week flew by like a day, and I came away with fascinating new insights into the medium.

I later interviewed Marilyn for *Becoming a Successful Artist*, adding an important chapter to that book. Her demonstration paintings found places in *Energize Your Paintings With Color* (North Light Books, 1993), and *Freshen Your Paintings With New Ideas* (North Light Books, 1994). Each time I worked with Marilyn, I became more convinced that her passion for painting and love of teaching made her an ideal candidate for a book of her own. North Light Books agreed and Marilyn was willing, so we quickly got to work. You're holding the result in your hands.

Capturing Light in Watercolor has truly been a collaborative effort. I interviewed Marilyn for uncounted hours, and recorded her energetic approach to art. I videotaped and photographed each demonstration, asked questions and recorded each comment and brushstroke. The words you read are Marilyn's. The images were captured as they flowed from her brush. The organization of the book is mine. It is a distillation of those images and words to bring to you, the reader, the experience of this wonderful artist's creative process.

Take some time to scan these pages; then return with brush in hand to paint along with Marilyn. Discover her world of watercolor insights for yourself. Tap into that special Simandle energy!

— *Lew Lehrman*

SCOTTISH HARBOR, 30″ x 22″

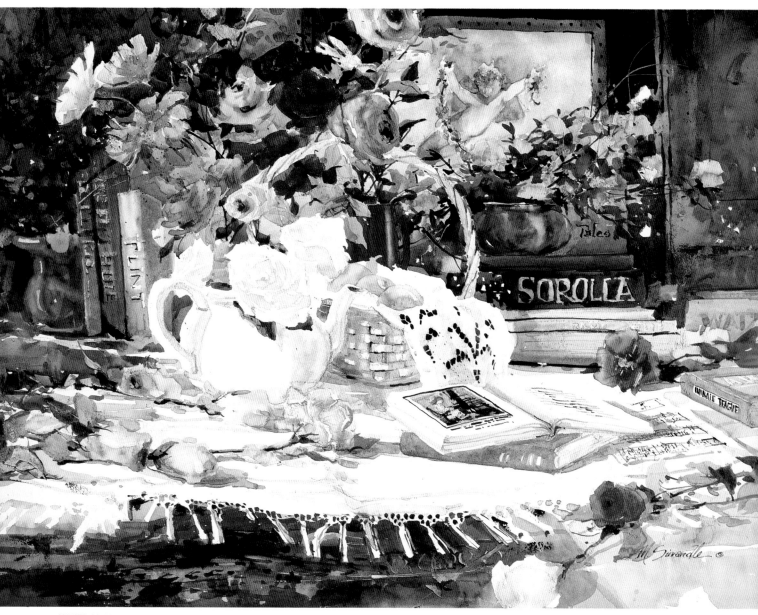

WHITE-ON-WHITE, 24" x 36"

THE ULTIMATE INSPIRATION

In the Bible, it says that God is light. God, the ultimate source of inspiration, is in all the light we see. *It is God's gift to each of us!*

Light, Life and Art

So much of what we treasure in our lives parallels what we strive for and require in our art. For example, just as we need light in our lives, we also seek out light in our art. Many people seek such things as simplicity, balance, design, harmony, excitement, diversity or unity. Aren't these qualities equally desirable in our paintings?

Focus also needs to be considered in both art and life. In a world so rich with possibilities, we often long to be good at everything without pursuing excellence in anything. It's wonderful to be interested in all kinds of things, but we often need to focus our efforts on becoming really good at one thing to truly achieve excellence. Finding a central theme and staying with it is all important. My point, simply, is this: Stay focused, keep at it, and you will get there.

MY EARLY LIFE

My life in art began very early, in a light-filled California home, at the side of my mother, a professional artist. Always a painter, I wasn't always sure what kind of painter I wanted to be when I grew up. I took lots of commercial art classes in college, and graduated with a marvelous portfolio, which I tucked under my arm as I headed for my first job interview. As I stood in the art department of a big department store, I wondered, "How far can I get here?" I looked around to see what the top guy was doing, and when I saw my answer, I knew I didn't want to paint for somebody else. I wanted to paint for myself.

That was a turning point. I put my portfolio and art aspirations aside to become an airline stewardess. I spent several exciting years flying all over the world, soaking up sights, sounds, scenes and experiences. When I'd had enough, I returned to art . . . but this time on my own terms.

MY LIFE IN ART

My passion is painting: Just supply me with paper and paints, and I'll be happy for the rest of my life. My husband, impressionist oil painter Ted Goerschner (whose own book, *Oil Painting: The Workshop Experience*, is also written with Lew Lehrman and published by North Light Books), shares that passion. We have been living, loving and painting together for over ten years. We share a bright, spacious studio in Santa Ynez, California, where we paint together nearly every day.

We especially enjoy painting in Europe. I'm like a whirling dervish when we travel. I can't wait to get to work. I'll do as many as six small paintings in a morning, and another three or four by nightfall. I can keep that up for weeks before I run out of steam. Ted is very much the same; we travel well together.

USING THIS BOOK

The following pages are full of insights and techniques that will add to your store of knowledge. Begin creating your own light-filled watercolors by getting out your brushes, following along with this book and painting through the demonstrations with me. I suggest you participate actively, brush in hand, as we cover the basics, then move on to the more advanced aspects of watercolor.

THE RIGHT QUESTIONS

Beginning artists ask so many questions. Believe me, I've heard every one! But they all boil down to what I call how questions and the why question.

In the beginning, how questions seem to be all that matter. You attend classes and workshops, read books, draw, paint, draw, paint. Before long, some of the things you struggled with at first no longer frustrate you. It's the path every artist travels.

Along that path, the why question emerges. At the outset, your answer to the why question should be "to learn." Though you won't always be satisfied with your results, take comfort in knowing that you learn more from your failures than from your successes.

The way you answer the why question as you progress has a profound effect on your future as an artist. For me, the answer is "because I love the process of putting down what I see." That's what I'm passionate about. Painting for the wrong reasons is a great enemy of creativity. I enjoy art least when the answer is "for the money." If you focus too much on selling, you miss out on the best part of painting; it should be fun.

Paint because you love the process of painting. You should always enjoy the journey more than the destination. I promise you an exciting, fun-filled journey; the rewards of capturing light in watercolor can far exceed your expectations.

Let's begin!

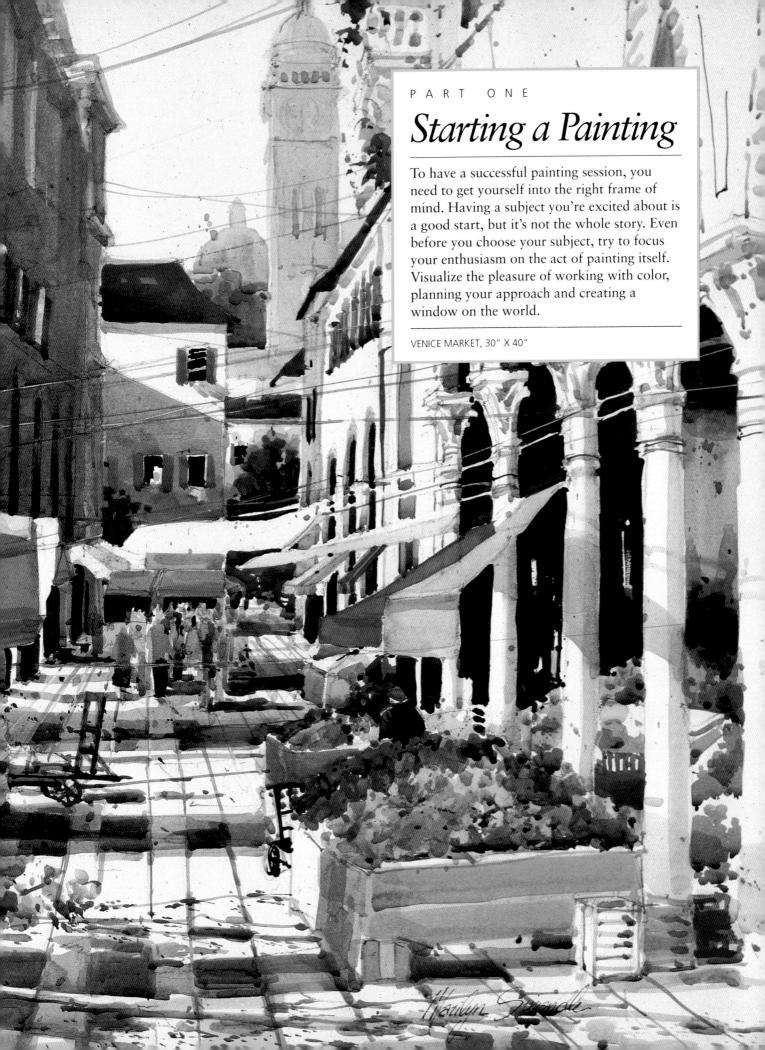

Starting a Painting

To have a successful painting session, you need to get yourself into the right frame of mind. Having a subject you're excited about is a good start, but it's not the whole story. Even before you choose your subject, try to focus your enthusiasm on the act of painting itself. Visualize the pleasure of working with color, planning your approach and creating a window on the world.

VENICE MARKET, 30" X 40"

My Way of Working

Whether in my studio, at a workshop, or painting outdoors on location, my working methods are pretty much the same. I paint every day, getting into the studio or on location by 8:30 or 9:00, whether I feel like it or not.

Painting itself gets me into the mood. If I waited around for inspiration, I wouldn't get nearly as much painting done. I've heard it said that if you paint three days a week, you'll maintain your skills. Anything more is better!

EASELS

The easel I drag everywhere—all over Europe, to workshops near and far, or just out to our flower garden—is my Russian easel. It's rugged, not too heavy, and lets me place palette, water and brushes right where I want them. The ever-popular French easel is good, but I find it neither as sturdy nor as steady. I use a large, solid easel in my studio.

PAPER

I do smaller paintings (less than 22" x 30") on stretched, 140 lb. cold-press watercolor paper. It has a tough, textured, durable surface that takes scraping and gouging without complaint. For paintings 22" x 30" and larger, I'll use 300 lb. cold-press watercolor paper. These papers are a joy to work with!

SKETCH PENCILS

I do all my sketching with 6B pencils, which are quite soft, allowing me to shade in shapes without using lines.

PIGMENTS

I have a strong preference for Winsor & Newton pigments. They're intense, clear, consistent, and available everywhere. Each time I begin a painting, I squeeze fresh pigments onto my palette. These include Antwerp Blue, French Ultramarine, Cobalt Blue and Manganese or Cerulean Blue; Alizarin Crimson, Scarlet Vermilion and Permanent Rose; Cadmium Orange; Raw Sienna and Burnt Sienna.

Cadmium Yellow is a wonderful, warm color, but I use mostly Raw Sienna and Burnt Sienna for yellows. I prefer to create greens with various blues mixed with Cadmium Orange, yellow, or Raw Sienna, so greens don't usually have a home on my palette. However, I do admit to a fondness for Sap Green, which occasionally shows up there.

There's no black on my palette. Black is a dead hue, and you should never use it. I want even my densest blacks to have life in them, so I mix them with Burnt Sienna and French Ultramarine Blue.

BRUSHES

I'm one of the very few watercolorists who's not a brush fanatic. Most of my painting is laid down with a well-broken-in floppy round, about a size 10 or 12. I keep a no. 2 synthetic bristle brush for darks and detail, and a no. 5 round for small shapes. Linear elements are laid in with a no. 5 rigger brush.

PALETTE KNIFE

One of my favorite tools is a small, very stiff palette knife, which I use for scraping, scratching and smearing. More about that on page 16.

MY WORK SETUP

Unlike many watercolorists, I prefer to paint standing up, with my paper in a nearly vertical position. Dribbles are not the problem you might think they'd be, since I don't do a lot of wet-in-wet painting. However, I do keep paper towels handy just in case.

On location, my board is held on the open lid of the Russian easel, my water bucket is clipped to one side of the easel, and the palette rests on top. I always paint in the shade. It saves my eyes and keeps me from painting my values too dark.

DISCOVER YOUR OWN WAY OF WORKING

As you become more and more comfortable with watercolor, experiment with different pigments, tools, and ways of working. That's all part of developing your unique personal style, and it's a big part of the fun!

A Brief Glossary

CALLIGRAPHY

Fine linear brushstrokes and scratched lines representing distant tree trunks, middle-ground tree branches, sailboat masts and such. Calligraphy adds rhythm, and gives the eye something to focus on.

CONTRAST

Any difference between elements. Maximum color contrast might be red against green. Value contrast might be black against white, or dark violet against light yellow. Masses can also contrast against each other in shape or size. Textures may contrast rough versus smooth. Contrast can be used for emphasizing the differences between dominant and subordinate elements in a painting.

DOMINANT AND SUBORDINATE

Dominant elements have more importance than subordinate elements in an artwork. Elements in a painting that play off each other should rarely be of equal importance; one should always be stronger, or dominant, while the other is weaker, or subordinate. The eye does not know where to look first when elements are of equal importance, resulting in confusion. Dominant and subordinate may apply to any of the elements mentioned in the definition of contrast above.

POINT OF INTEREST

The subject of a painting, where you want the eye to ultimately arrive. Everything else in your painting should emphasize the point of interest.

POSITIVE AND NEGATIVE SPACE

Positive space is the area containing the subject matter in a composition; negative space is the area not occupied by subject matter. The easiest way to understand this is to visualize a figure with hands on hips. The positive element is the figure itself; the two triangular areas between arms and body, as well as the entire area around the figure, are negative space.

VALUE

Degree of lightness or darkness. Light colors are said to be high value, or high key. Dark colors are low value, or low key. Yellow is by nature a high-value color, but it might have the same value as a light gray. A drawing rendered in black and white works because it consists solely of differing values.

STRETCHING WATERCOLOR PAPER

You need watercolor paper, a spray bottle of water, paper towels, gummed brown paper tape (the kind you moisten with water, not the already sticky kind) and a smooth board (plywood, Masonite, etc.). Relax the paper by spraying both sides with water, then wipe with a paper towel. Wet tape strips with the damp paper towel (the key to getting the tape to stick properly is not getting it too wet—just moisten it). Tape the edges of the sheet to the board and let it dry overnight. It will shrink flat and be ready to paint on in the morning. I usually have a batch of stretched sheets on boards in my studio. After you're finished painting and your piece is dry, cut it away from the tape. It will be flat and ready to frame.

Use a Palette Knife!

As you leaf through these pages, you'll see that a palette knife is a very important part of my work kit. Who says only oil painters get to use one?

My preferred palette knife is long, with an angled end. The blade is small, narrow and very stiff. I keep it handy as I paint, and while a particular color passage is still wet, I put it into play. Here's how:

1. Scratching

The rounded tip is perfect for scratching out tree branches, boat masts, mooring lines and such. If the wash is still moist, the scratch will be white. Where the wash is glistening wet, the paint will be drawn into the scratch and turn dark. You'll have to work quickly, before your wash dries. You can often rewet a dried wash to scratch it.

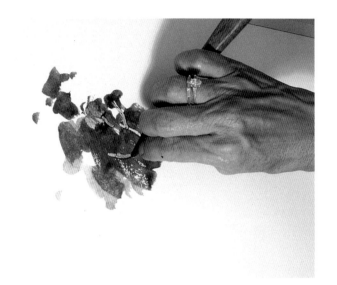

2. Squeegeeing

Hold the blade of the knife so a long edge is against the wash. Moving it as shown will squeegee most of the wet or moist color away.

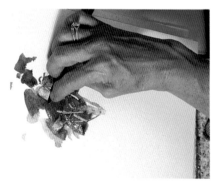

3. Smearing

Pressing the flat bottom of the knife blade against the wet wash, you can smear the moist paint to create texture.

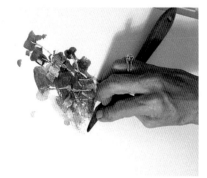

4. Applying

You can also apply paint with your palette knife, just like an oil painter. Here is a gob of paint on the bottom of my palette knife . . . and here I smear it directly onto the paper. Different results occur when the paper is wet, dry, painted or unpainted—often a great deal of accidental texture. Experiment with this technique, but don't try to control it too much.

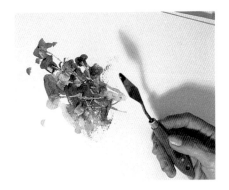

5. Dragging

If you tip the palette knife on edge and pull it in a slicing movement, you can drag out a narrow line of paint. This isn't easy to control, however, so be prepared for (and accepting of) surprises!

6. Moving Color Around

You can dip your palette knife in water and use its flat bottom to move color around, especially if you have applied it as in the two preceding examples. Depending on paper surface, degree of wetness, etc., you'll achieve interesting random effects this way. Again, it's not all that easy to control, so expect the unexpected!

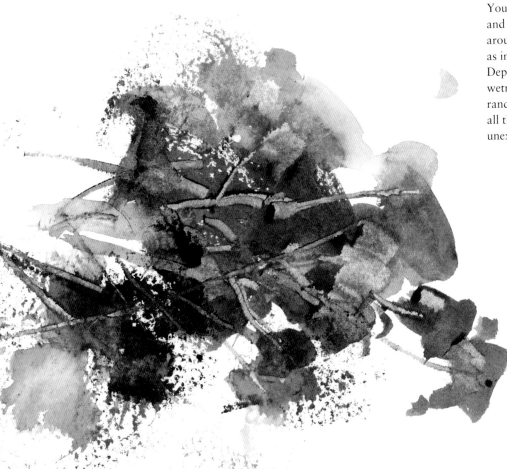

Create Your Own Scene

Have you ever wasted valuable hours leafing through your photo file or driving down the road, searching for just the right subject? It's an easy trap to fall into. No scene is perfect. At the very least, you have to edit out light poles, litter, parked cars and billboards.

So why stop there? Once you realize that your painting is altogether separate from the reference you're using, you're free to simplify, rearrange, combine and improve—in short, to remake the scene the way you wish it looked. When I paint, I'll often combine elements from ten or more photos in a single painting which ends up far better than any of them!

Let's start with these two photos, and see where this kind of process can take us:

TINKER WITH REALITY!

Wouldn't it be nice if that walkway in the photo at left led down to a harbor like it does in the one on the right? How about a riot of blossoms to soften the line of the wall? Is the hillside too complex? Simplify! Is the light too harsh? Soften it!

Work out your ideas with a series of quick thumbnail sketches. They take only seconds to do. As you sketch, look for pleasing patterns of lights and darks.

Nice shape, but it blocks up the center of the picture

The town is too far away to see

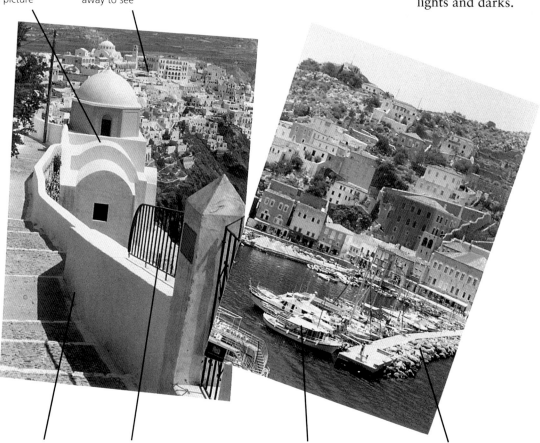

Great shadows! The walkway leads you right in.

These wrought iron gates are uninteresting.

Too many boats? Moor just a few along the shore.

Is the pier too complex and intrusive? Leave it out!

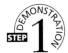 STEP 1 Draw Thumbnails and Value Sketches

Try out lots of variations with thumbnail sketches. When you arrive at one you like, do a slightly larger value sketch, working out a pleasing pattern of lights and darks. If necessary, do a second, or even a third. Think about eye movement around the painting.

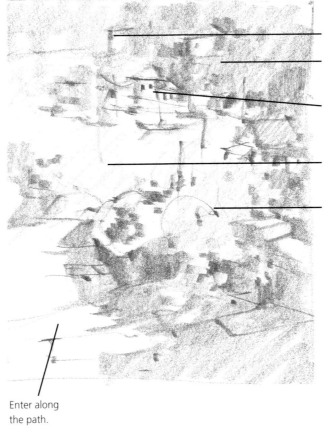

Discover other middle ground buildings and background.

Move into the middle ground.

Linger to enjoy the light and contrasts in the center of interest

Move down towards the water.

Pause at the foreground flower mass.

Enter along the path.

STEP 2 Build the Right Foundation

Use a soft 6B pencil to sketch with broad movements on your stretched watercolor sheet, keeping erasures to a minimum. No detail, just big shapes. Details will come later.

Add a few smaller buildings as secondary points of interest, but make sure the main one dominates, and that no two are of quite the same importance.

Start with the pathway.

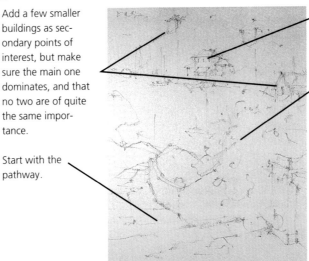

Rough in the building that will be the center of interest.

Rough in the foreground flower mass.

STEP 3 Capture Light With First Washes, Biggest Shapes First

Paint the biggest shapes first. Mix a warm, high-chroma wash of Permanent Rose and Cadmium Orange for the flower mass in the fore-ground—a bright and important element. Don't worry too much about the shape. Make it up as you go, but keep it interesting. Be sure to leave little areas of white open to create the sparkle of light.

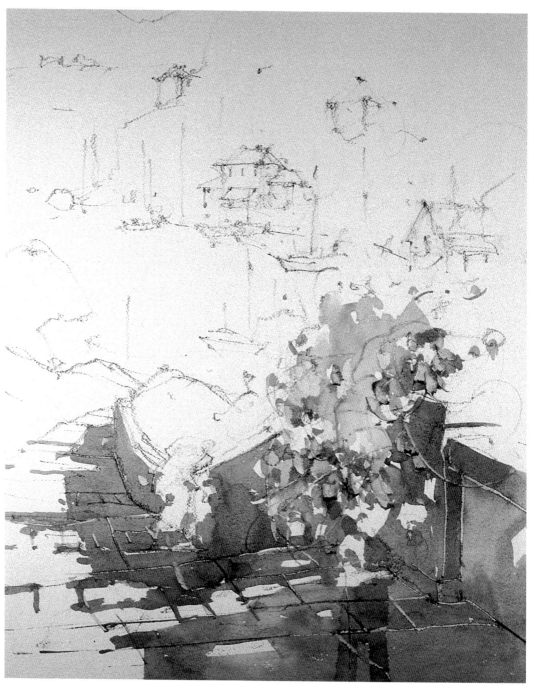

A CLOSER LOOK

The shadow shape, which establishes the brightness of the sunlight, is the largest mass in the painting. It is also an entry into the painting, so it has to be kept simple.

Raw Sienna added to the violet wash.

These greens are made up of Manganese Blue and Raw Sienna. Where washes meet, break up edges by moving color into the adjoining wash.

Lines stay light when scraped while wash is damp.

Shadow wash, started here, is based on a triad of Manganese Blue, Permanent Rose and Raw Sienna.

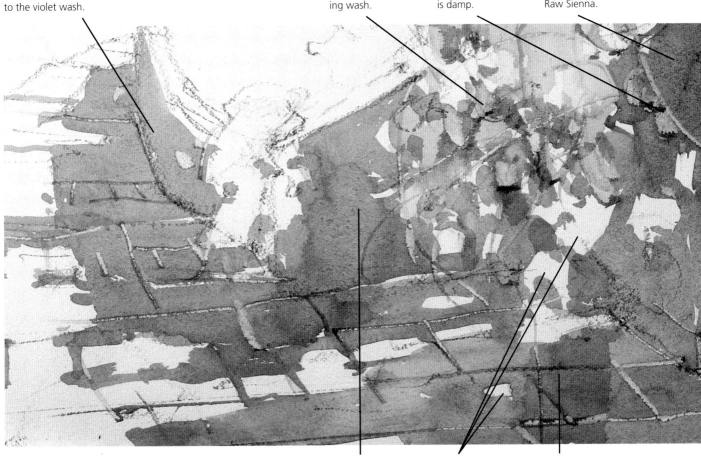

Permanent Rose and Raw Sienna warm the wash. Add new color to change the wash each time you recharge your brush.

Lots of whites left open for light and sparkle.

Lines turn dark when scraped while wash is quite wet.

STEP 4 Form the Next Largest Mass

See how strongly the two masses contrast with each other.

A CLOSER LOOK

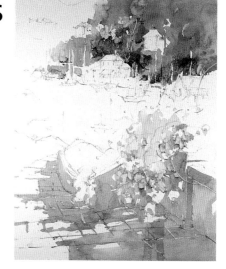

Edge softened with water-moistened brush.

Whites preserved for sparkle.

Wash warmed with Cadmium Orange.

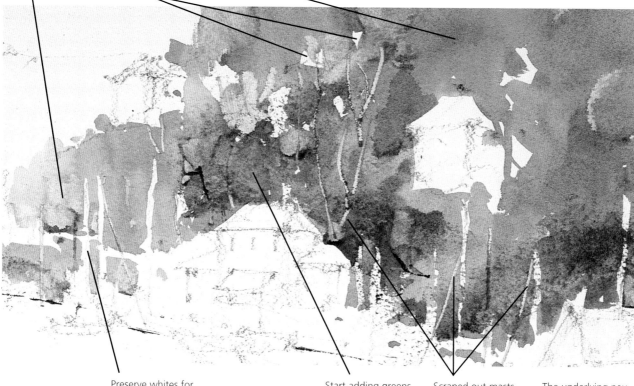

Preserve whites for masts.

Start adding greens into the wash, using these darker values to begin framing the center of interest.

Scraped out masts and tree shape.

The underlying neutral wash is mixed with Raw Sienna, Cobalt Violet and Cadmium Scarlet.

⑤ Tie the Masses Together

Begin background here, with Ultramarine Blue and Permanent Rose, then move down and to the right. Be sure background stays cooler and more distant than the hillside.

Masts light against dark background, dark against white.

Use the violet wash to imply shadows and details in the middle ground.

Continue building values with greens.

Begin detailing the center of interest.

Preserve whites for reflections and waterside details.

Shift to Raw Sienna here, warmed with a touch of Cadmium Orange.

Scrape lines in wet wash to show water flow.

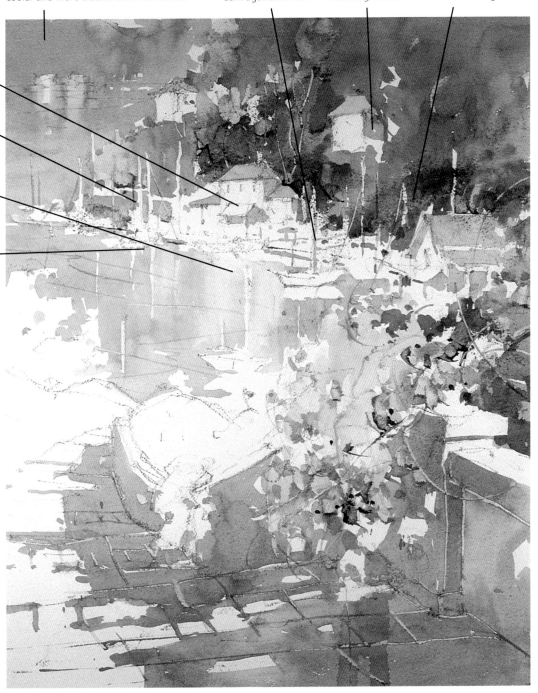

STEP 6 Bring It to Completion

Complete the minor details. At this stage, begin to push (brighten) colors and increase contrasts to emphasize the light.

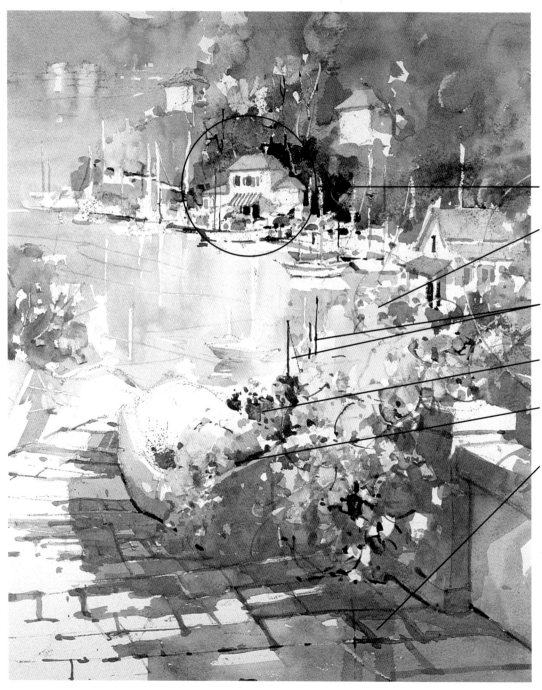

Accents of dark and bright color in the center of interest.

Move bright pink into and around the picture.

Use a rigger brush for linear details, making sure to break up the lines.

Build dark values with varied greens.

Glazed-in Permanent Rose adds depth to the pinks.

Add darker accents in the shadows.

Add Final Touches

Sunlight sparkles along the pathway and throughout this harbor scene. Strong contrasts in greens and shadow-violets emphasize the brightness of the clean, unpainted whites.

Note the stronger contrasts and colors in and around the center of interest. Outside the center of interest, houses are toned down with Raw Sienna.

Also notice how oranges, reds and Alizarin Crimson brighten the center of interest. People, parasols, and an awning are suggested with very little actual detail. Think shapes!

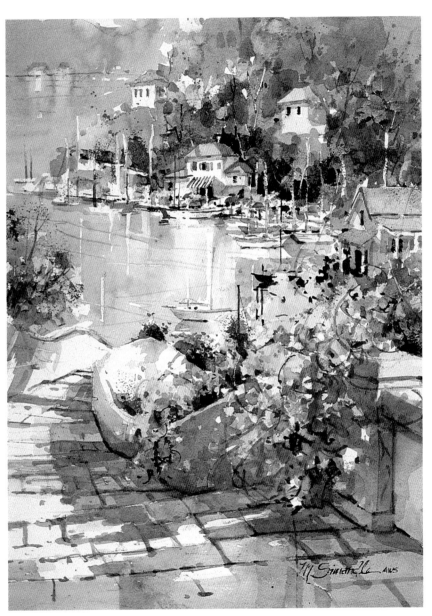

BAY VIEW, 18" X 14"

Everything Begins With Design

You see a painting on a wall, and it grabs your attention. The sparkle of light, the feeling of life —how *did* the artist achieve that? As you focus in for a closer look, your eyes move through the foreground and middle ground to the center of interest; you discover visual surprises here and there in the piece, not wanting to leave it.

You might never consciously realize it, but the way your eye moves through a painting is usually carefully planned by the artist. Influencing eye movement is a primary purpose of design, or composition. Design is the placement of pictorial elements, such as values, lines, colors, and especially shapes, within a given format.

Harmony is a pleasing combination of elements that creates order, agreement and balance in a design; diversity is a variety of elements used to create interest; simplicity is an uncomplicated combination of elements; and rhythm is the regular repetition of one or more elements. In order to successfully capture light in watercolor, it's well worth taking the time to understand how design works.

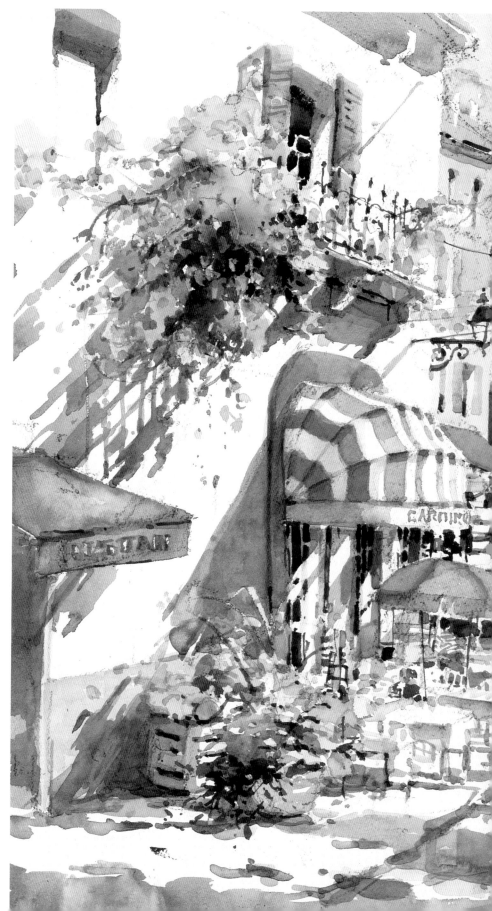

SEASIDE WALKWAY, 22″ X 30″

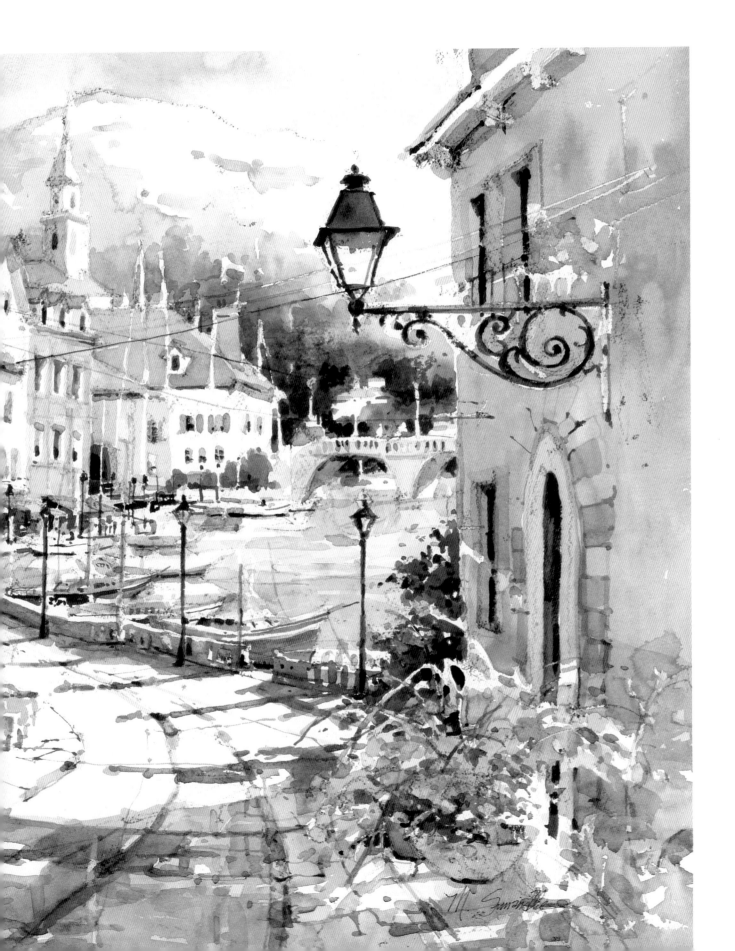

Looking at Shapes

Whether distinctly drawn or merely implied, shapes are the building blocks of every painting, because design is primarily based upon how shapes are placed within a given format. Every painting is made up of shapes. Not trees, not houses, not mountains. *Shapes*. A shape is anything on a painting that is defined or suggested by paint. Even the *absence* of paint creates negative shapes, which are formed by the space in an artwork not occupied by subject matter. There are three basic types of shapes: organic, geometric and abstract.

Organic Shapes

Organic shapes suggest something in nature, such the foliage of a tree, a mountain, or shadows on a hillside. Because they suggest nature, they naturally have meaning to the viewer.

Abstract Shapes

Non-geometric, abstract shapes are not based upon realistic representation of subject matter; they do not communicate with the viewer unless the composition itself is appealing. I remember reading about a survey in which people were asked for their reactions to basic shapes. The most pleasing and most easily-remembered shapes were simple geometric shapes. Organic shapes were nearly as pleasing and memorable. Interestingly, abstract shapes were reported as being the least appealing. So if we accept that art is communication, it is least likely to seem appealing when it is predominantly abstract.

Geometric Shapes

Simple geometric shapes include circles, squares, triangles, rectangles, ellipses, spheres, cubes, cylinders and cones. These shapes are most often used in portraying synthetic objects such as houses, roofs, wheels and the like; yet they're also found in human figures, tree trunks, and other natural objects.

THE IDEAL COMPOSITION

The ideal composition usually includes a combination of organic, geometric and abstract shapes.

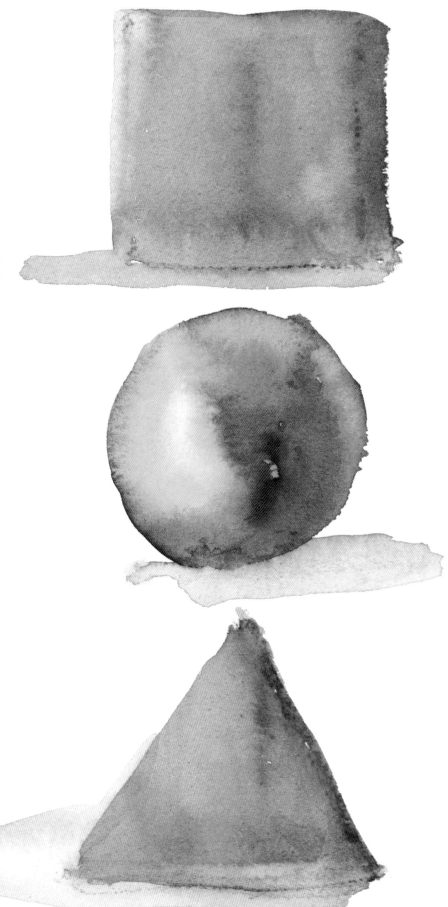

Simplify by Seeing Objects as Shapes

Simplicity is an uncomplicated combination of elements that comes back to working with shapes and design. As you gain experience analyzing what you see, you'll be able to represent complex subjects as simple shapes that can be manipulated effectively to focus on a subject. Grouping or moving elements, such as trees and buildings, can enhance your subject; eliminating elements can avoid detracting from it. You'll learn to emphasize your point of interest by contrasting areas of detail with areas of simplicity. The more you simplify, the stronger your paintings will become.

Simplify House Shapes
A house is really nothing more than a few geometric shapes, such as squares, cubes and triangles.

Simplify Human Figures
Even the human figure can be composed with squares, cubes, ellipses and cylinders.

Simplify Tree Shapes
Painting this tree mass exactly as it looks would be a complex, time-consuming task. It can be easily simplified to a large cube shape for the foliage, and cylindrical shapes for trunk and branches.

Static and Dynamic Shapes

Static shapes seem to sit motionless, or fixed, on the paper; dynamic shapes suggest movement in some direction. Squares and circles are generally static. Triangular shapes are dynamic, since they tend to move your eye in the direction they're pointing. A shape that appears to lean in a certain direction suggests movement in that direction. Edges and lines move the eye along their length.

Suggestion of Movement
The receding bridge and its shadow form a dynamic, triangular geometric shape pointing towards the horizon that directs your eye. Abstract and organic shapes can suggest movement as well.

Create Eye Movement

An Interesting Scene

Let me show you how the placement of shapes can create harmony through eye movement by using this interesting scene. Should I try to capture every detail in this photo? Good luck! Not every weed, shingle and railing is necessary! It's the light, the mood, the overall look, that I want to capture.

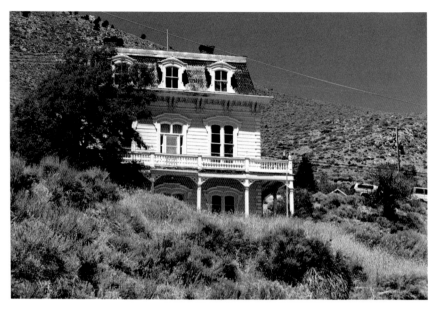

Basic Shapes

I start simplifying by reducing this subject to its basic shapes as I sketch the scene. I leave out smaller, unimportant, duplicated shapes that don't enhance the effect I'm trying to achieve. What I'm really doing is distilling the scene to its basic elements. Now I can experiment with placement of elements, free from all that burdensome detail. Compare these sketches to the photo to see how much I've left out. Not only will it be much easier to paint, the finished painting will be stronger than one painstakingly copied from a photo.

MOVEMENT IN MODERATION

Lines and edges are so powerful at moving the viewer's eye that I usually have to moderate them by introducing little bends, breaks and turns, especially in vertical elements, to stop the eye from moving too quickly!

Eye Movement

To show eye movement, I've added arrows to my final sketch. Note how the eye enters at the foreground and moves up the triangular road shape towards the middle ground. The eye continues around the curve of the road to arrive at the point of interest, the house. It continues to the background and up into the trees. No detail in this sketch, just shapes!

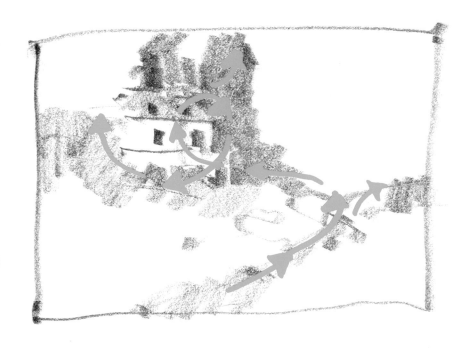

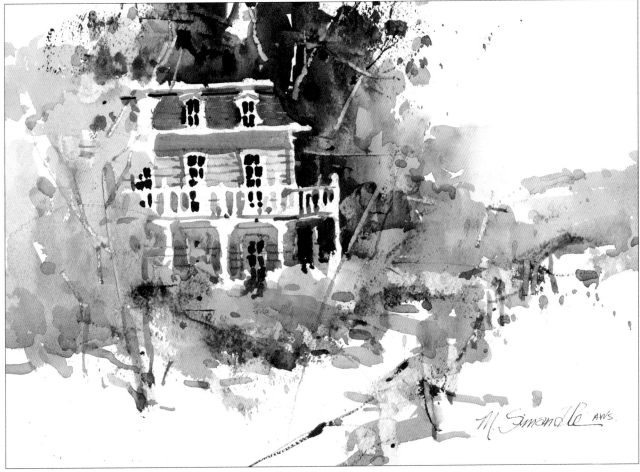

VIRGINIA CITY, 9" X 12"

Rhythm and Repetition

RHYTHM OF SHAPE

Many things in our lives—days, seasons, heartbeats, daily routines, music—have a pattern of repetition we call rhythm. Visually, rhythm is the regular repetition of a design element expressed as a pattern. Because we instinctively look for pattern and repetition, our eyes move easily through a composition when its shapes, lines, colors and values repeat in an interesting, harmonious way. Rhythmic movement is easy to create with repeated shapes, and may be found in the pickets of a fence, grout lines on a tile floor, roses in a vase, the patterns of fabrics, striped awnings, furrows in a plowed field—the possibilities are endless.

RHYTHM OF LINE

I love using rhythmic line work in my paintings. That's one reason I enjoy using my palette knife to scratch into my washes. Tree branches, lines of siding on a building, or telephone wires in a street scene can form an exciting pattern to move your eye toward a point of interest.

RHYTHM OF VALUE

The ways that dark, middle and light values move around a composition can also be used to add rhythm. Though there are times when a narrow value range is more suitable for a particular subject, I believe in using a full scale of lights and darks to create drama in my paintings.

RHYTHM OF COLOR

One way to create appealing color rhythms is, when using a color, to repeat it elsewhere in your composition. As the viewer's eye perceives that color, it unconsciously seeks out the same color elsewhere. When I mix a wash, I mix enough to use in several areas, not just one.

DON'T PAINT WALLPAPER

While emphasizing rhythm, I want to point out the importance of keeping your rhythmic patterns interesting. A single element endlessly, mindlessly repeated with neither variation nor resolution can quickly become boring. Like wallpaper, it has no point of interest. What works for wallpaper won't work in your paintings!

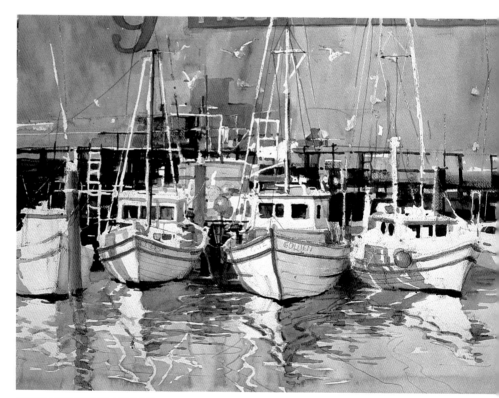

FISHERMAN'S WHARF, 18" X 24"

1. Rhythmic Shape Pattern
Here's an example of rhythm and pattern using a single value but different shapes.

2. Harmony and Diversity
Here you see rhythms created with the same shapes (harmonious), yet different values (diverse), as dark and light brushstrokes add depth and interest.

3. Shape, Value, Color
I've added simple squares which contribute their own rhythm with their pattern of shape, value, and color contrast.

Rhythmic Repetition
Several elements repeat rhythmically in this painting; the patterns of the arches, boats, boat masts and windows.

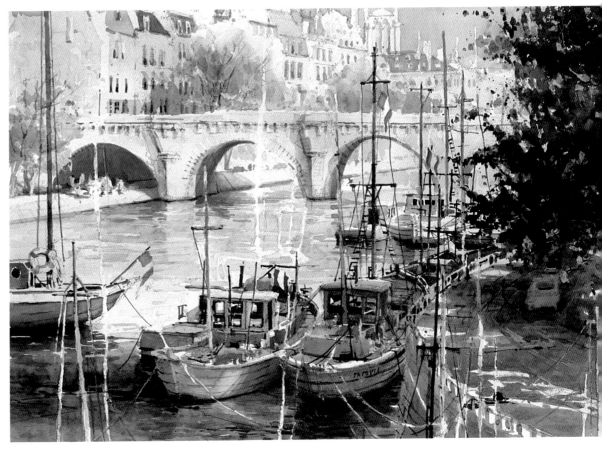

ON THE SEINE, 22" X 30"

Rhythm and Repetition

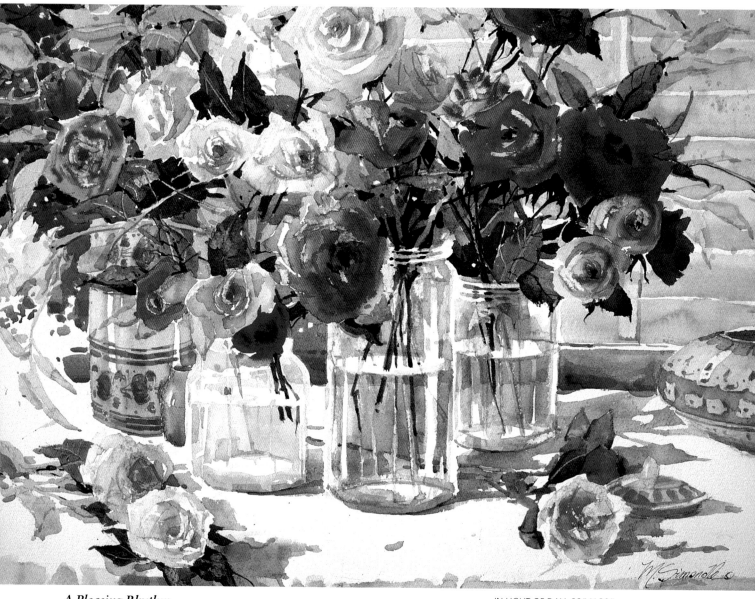

A Pleasing Rhythm
The repetition of shapes, lines and colors in this piece creates a pleasing rhythm.

IN LIGHT OF DAY, 22" X 30"
Published by Art In Motion, Canada 1993

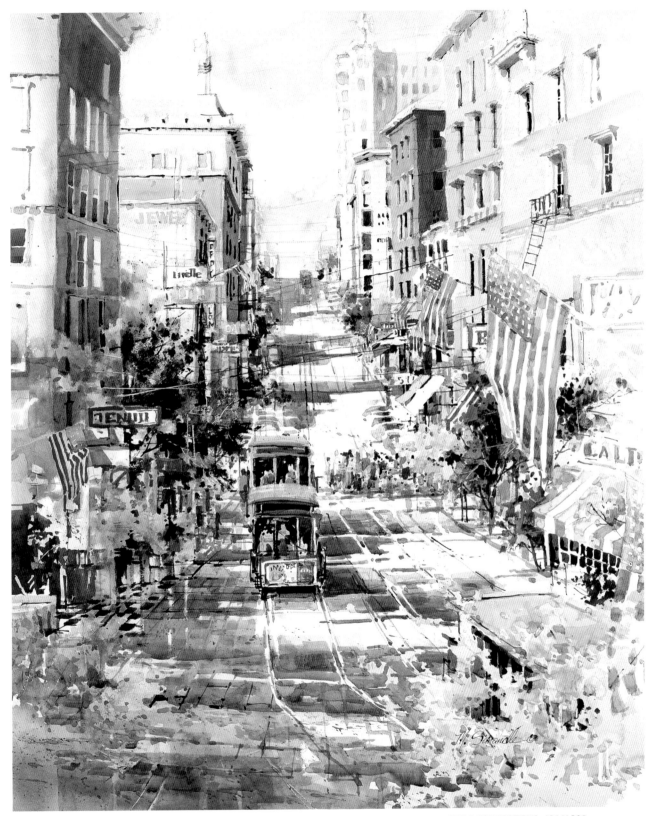

Rhythm at Work

Here's a good example of rhythm at work. Though this piece may appear busy, even chaotic at first glance, it is built upon rhythmically repeating shapes, lines and colors: the underlying organization that holds its many elements together.

Harmony

Harmony in art is no different from harmony in life. Elements in a painting, like people, are in a harmonious relationship with each other when they have things in common, when they agree, and when they feel comfortable with each other.

Pleasing Visual Harmonies

This painting's visual appeal is enhanced by the pleasing harmonies present in it. The dominant hues are yellows (Burnt Sienna, Raw Sienna) oranges (Cadmium Orange), pinks (Permanent Rose) and reds (Cadmium Scarlet). These are analogous colors that adjoin each other around the color wheel. The eye moves easily from one to the next because they are similar, as are the predominant values, which also enable the eye to move easily among them (there is greater contrast in the center of interest). The related nature of the repetitive and similar shapes in this painting invites the eye to move among them easily as well, without encountering abrupt changes.

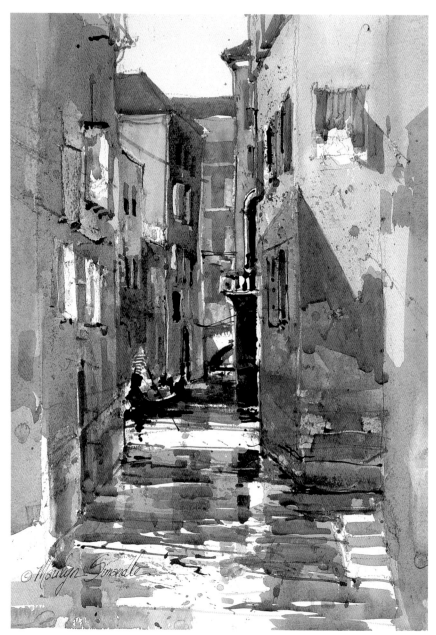

VENICE CANAL, 16" X 12"

Analogous Colors Harmonize
Analogous colors adjoin each other
around the color wheel.

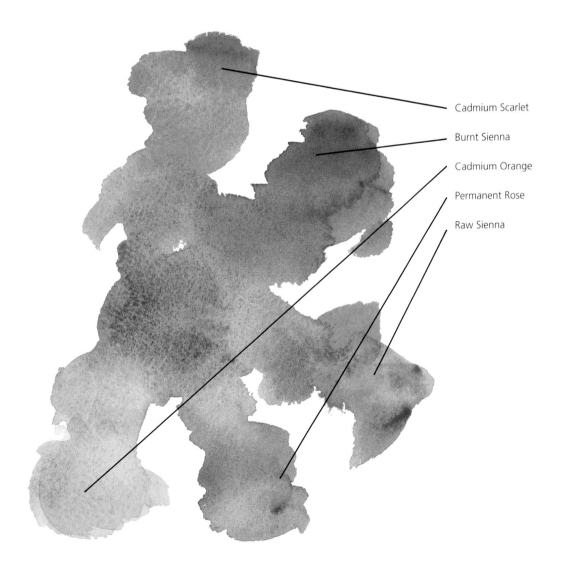

Cadmium Scarlet

Burnt Sienna

Cadmium Orange

Permanent Rose

Raw Sienna

Harmony

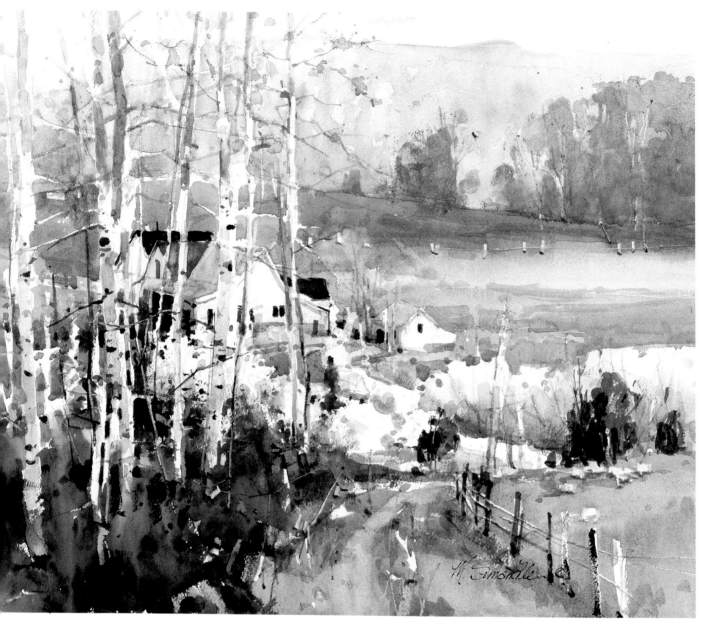

Color, Value and Line Harmonies
An analogous palette of violets, blues and greens, in similar values, dominate this painting for a harmonious effect. The treatment of the linear elements — painted with a fine brush, scratched in, and using lost-and-found edges — keeps repeating tree shapes related yet interesting.

FIND HARMONIOUS COLOR RELATIONSHIPS

Harmonious colors in the world around us give us pleasure: the warm brilliance of autumn foliage, the pastel shades of a sunrise, the infinite greens of a forest, the fading hues of mountains layered to the horizon.

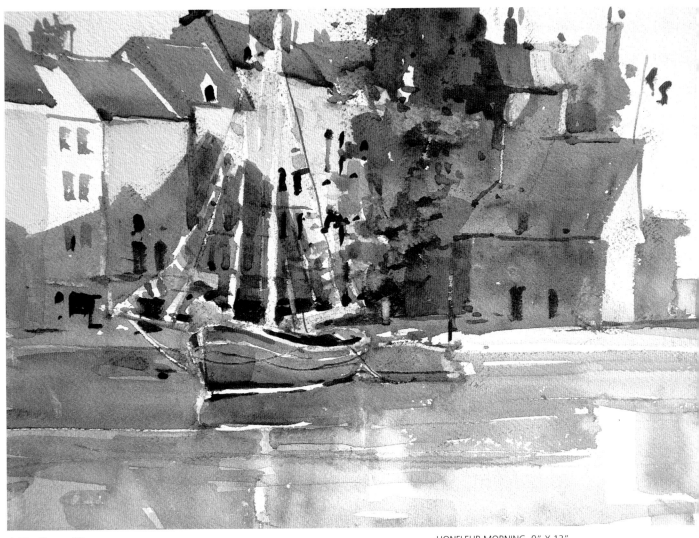

A Feeling of Peace
This painting conveys a feeling of peaceful calm because its elements are harmonious. Analogous color, smooth value transitions, and static shapes help communicate that emotion.

HONFLEUR MORNING, 9" X 12"

Diversity

Diversity, or contrast, is in many respects the flip side of harmony. As harmony is based on the similarity of elements, diversity emphasizes the differences between them. Harmony conveys a sense of peace, calm and order. Diversity communicates action, excitement and energy. Diversity can take many forms, and might combine characteristics of shape, color, value, line or texture.

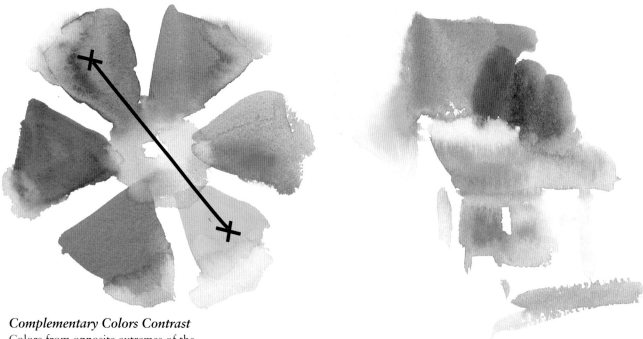

Complementary Colors Contrast
Colors from opposite extremes of the color wheel, called complementary colors, contrast most strongly.

Lively Contrasts
This painting conveys a feeling of excitement and life because its diverse contrasts dominate its harmonies, though both are clearly in evidence. The oranges in this painting strongly contrast with their complement, blue. The swatches below clearly indicate the nature of this color scheme.

The dark green tree mass and windows strongly contrast against the adjoining whites and oranges. Organic foliage and water shapes contrast with geometric houses. Strong vertical elements contrast with horizontal masses, edges and lines.

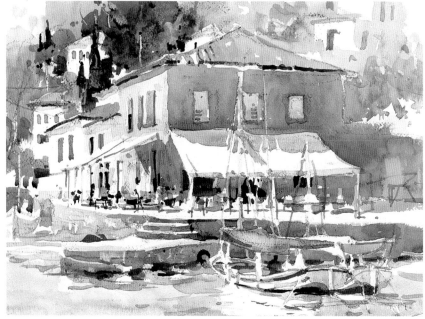

HYDRA, GREECE, 9" X 12"

BALANCE HARMONY AND DIVERSITY

The paintings we look at affect us in many ways. Some are calm, peaceful and soothing. Others are exciting, energetic and joyful. They convey these impressions because they combine harmony and diversity to differing degrees. Harmony unifies, diversity excites. In a way, harmony and diversity are opposite sides of the same coin. Both should be present in every painting, and the degree to which each dominates and plays against the other helps determine the mood of the piece.

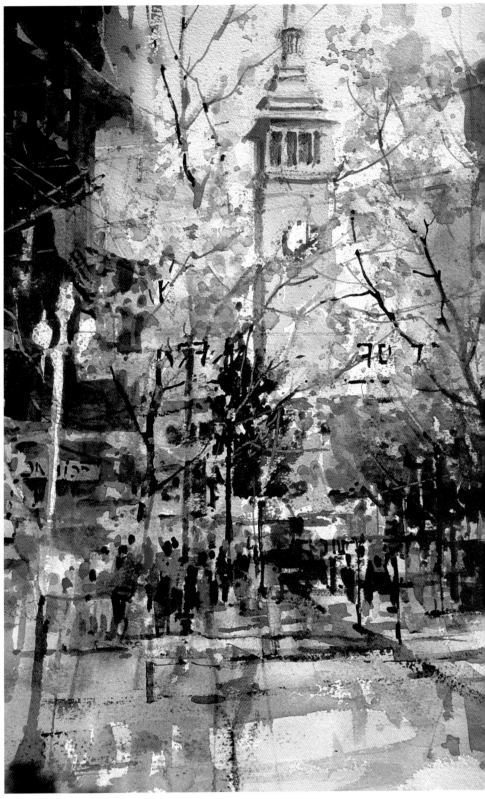

THE FERRY BUILDING, SAN FRANCISCO, 16" X 12"

Life and Excitement
This painting throbs with life and excitement. Bold color contrasts, strong value contrasts, and dynamic shapes were all part of my plan to achieve that effect.

Put It All Together

There are countless ways to balance harmony and diversity in your paintings. The mood you wish to establish in a particular painting determines just which will dominate, which is why it's so important to decide the feeling you want before you begin. The secret is in the planning; the decisions you make before your brush touches your paper make all the difference at the finish. That balance of harmony and diversity isn't something you can plug in later!

As you work your way through the following chapters, be alert to the harmonies and diversities in each example. They are your key to answering two important questions: "What makes this painting work?" and "How can I use that to get my paintings to work?"

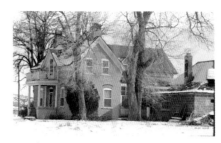

Make Decisions Before Painting
I photographed this house in the snow because I enjoy its shapes and the way it's nestled in the trees. I don't love the cinder block structure at right, however, so I move and change it in my composition. I will also rearrange the trees to give the house more room.

Plan Harmony and Diversity While Sketching

I think of the rhythm of repeating roof shapes, a fragment of fence in the foreground, and the railing of a porch as I sketch the scene. I'm planning strong vertical tree elements against the horizontal mass of the buildings. I'm setting up the contrast of organic foliage shapes against geometric shapes of the house. I'm also thinking about my color harmonies. I want to use an analogous color scheme ranging from green, through yellow, to orange. Value contrast will consist of dark foliage against the light values of house and background.

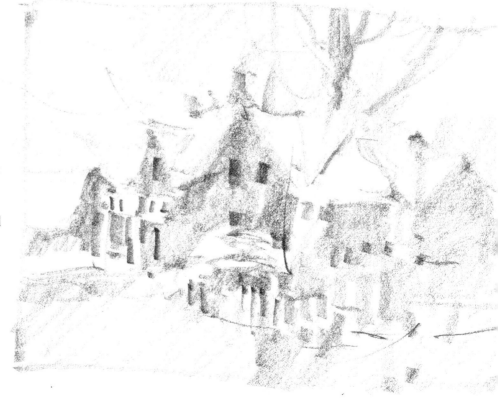

STEP 2 Establish Color Range

My initial wash establishes the green-to-orange color range.

STEP 3 Create Rhythmic Shapes

A second wash establishes a darker passage of the same color while creating the rhythmic shapes of the roof lines.

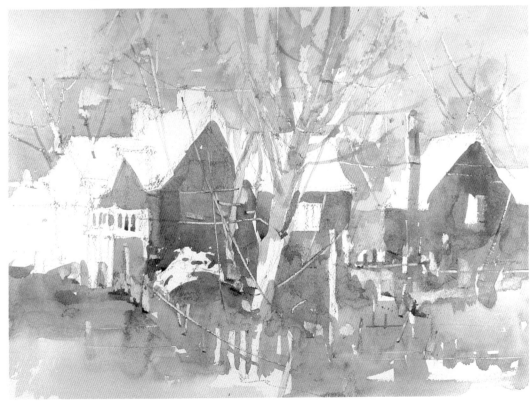

STEP 4 Add More Rhythm

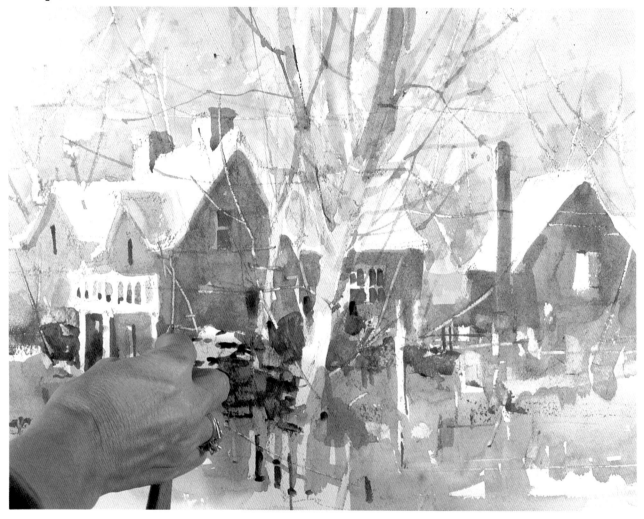

With a rigger brush and palette knife, I begin to add rhythmic lines in tree branches, siding lines and such. Geometric window shapes are another instance of repeating, rhythmic shapes.

BALANCE SIMPLICITY WITH DETAIL

A painting is a form of communication that is not complete until it has evoked a response, thus achieving a conversation between artist and viewer. The conditions have to be right for that communication to happen. Too much detail in your painting leaves nothing for the viewer to imagine: It's as if you were dominating the conversation. Too little detail, on the other hand, might be compared with leaving out important words and phrases; there is neither communication nor understanding. Something between these extremes awakens viewers' imaginations with the power of suggestion, and their response completes the communication. Thus, there must be a balance between simplicity and detail.

5 Set the Mood With Harmony and Diversity

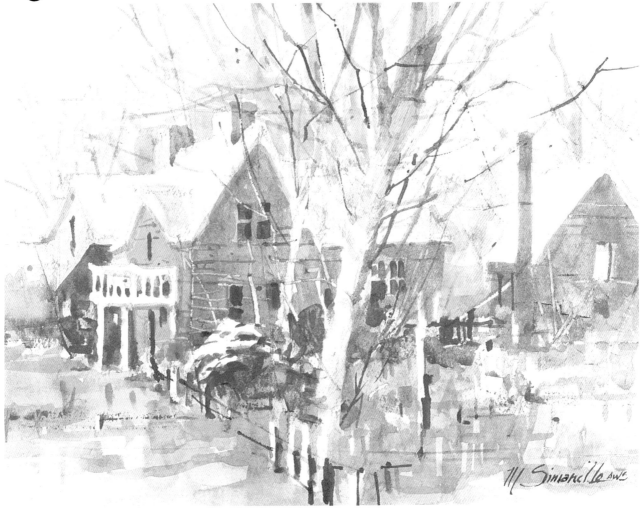

THE YELLOW HOUSE, 12" X 16"

The mood of this painting is a blend of peacefulness and liveliness due to the harmony of color and shape as well as the diversity of line and value.

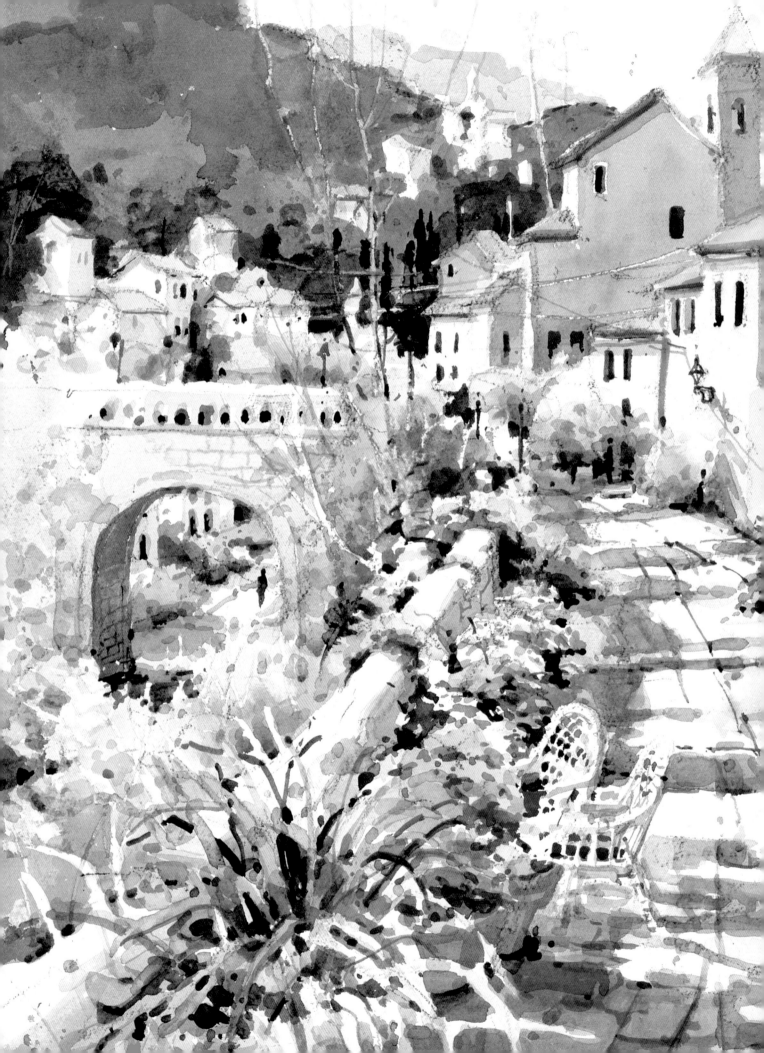

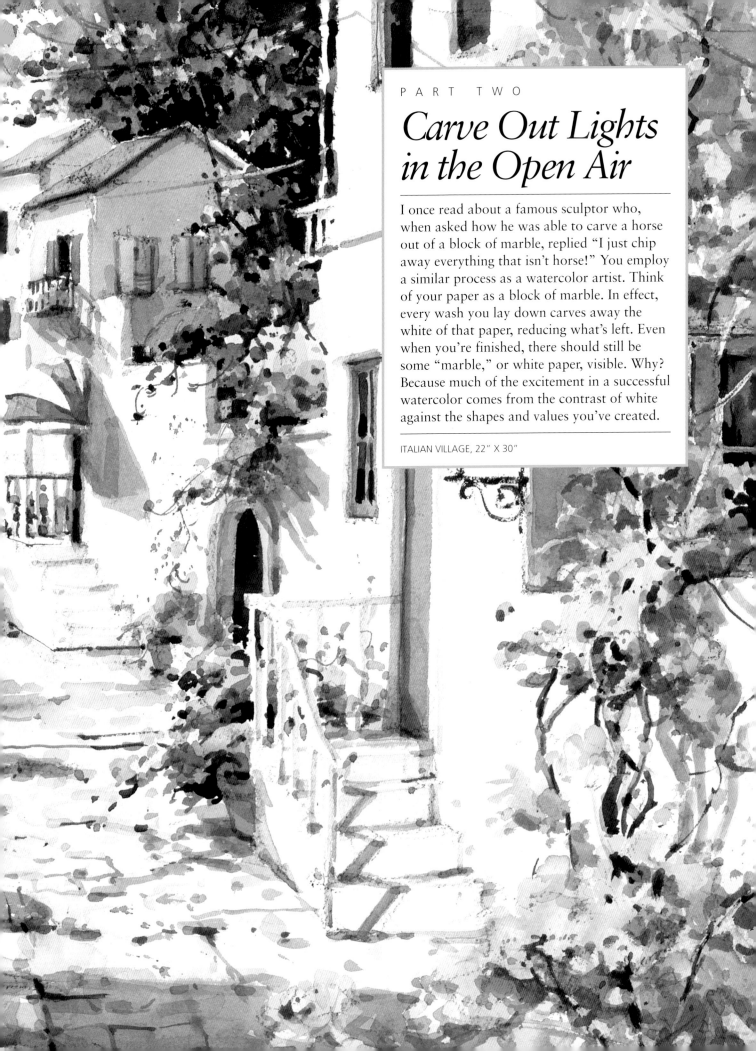

Carve Out Lights in the Open Air

I once read about a famous sculptor who, when asked how he was able to carve a horse out of a block of marble, replied "I just chip away everything that isn't horse!" You employ a similar process as a watercolor artist. Think of your paper as a block of marble. In effect, every wash you lay down carves away the white of that paper, reducing what's left. Even when you're finished, there should still be some "marble," or white paper, visible. Why? Because much of the excitement in a successful watercolor comes from the contrast of white against the shapes and values you've created.

ITALIAN VILLAGE, 22" X 30"

Create Brilliant Brights

PLAN IT OUT

Take a look at these two photos of Greece. Ignore the fact that the scene beside the pier was photographed in the flat light of a cloudy day; visualize bright sunlight, dazzlingly white buildings and colorful boats bobbing in a sparkling harbor. It's the perfect watercolor subject! What will make this subject work is sunlight contrasting against shadowed masses. You'll carve out your whites by painting around them. Highlights will dazzle because they play off against color-filled shadows. Decide where the light should come from. Bringing it in from the right illuminates building facades but allows for few shadows. Light from the left throws building facades into shadow, which can be used to contrast against highlighted masts, awnings, building flanks and promenade. That's the way to go!

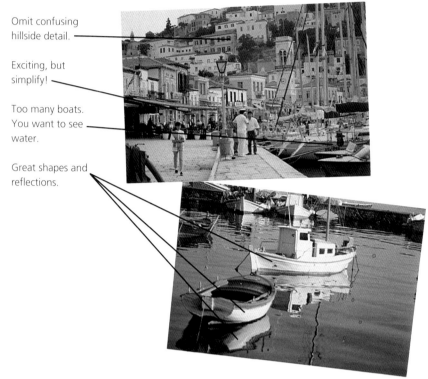

Omit confusing hillside detail.

Exciting, but simplify!

Too many boats. You want to see water.

Great shapes and reflections.

STEP 1 Start With Thumbnails and Value Sketches

Grab your pencil and try your own interpretation of the scene with some quick thumbnail sketches. Remember to simplify values to white, middle and dark. The large building-front shadow mass frames the scene, making highlights pop! Play with different arrangements. For example, try reversing the foreground as in my second sketch.

When you've arrived at a value pattern, try one or more value sketches to further develop the composition. Simplify, using fewer buildings and boats for less clutter. Distill the scene down to its essence.

See how I hold my pencil? Standing at arm's length from my paper and using the broad side of the lead lets me quickly sketch large, dark masses without getting bogged down in detail.

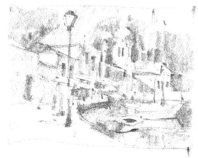

STEP 2 Lay the Foundation

Transfer your simplified composition to stretched watercolor paper, developing it as you go. This sets you in the right direction. Here I've used the skiff from the photo, but changed the other boat's structure to that of a sailboat rig, creating a strong vertical that contrasts with the horizontals of promenade and buildings.

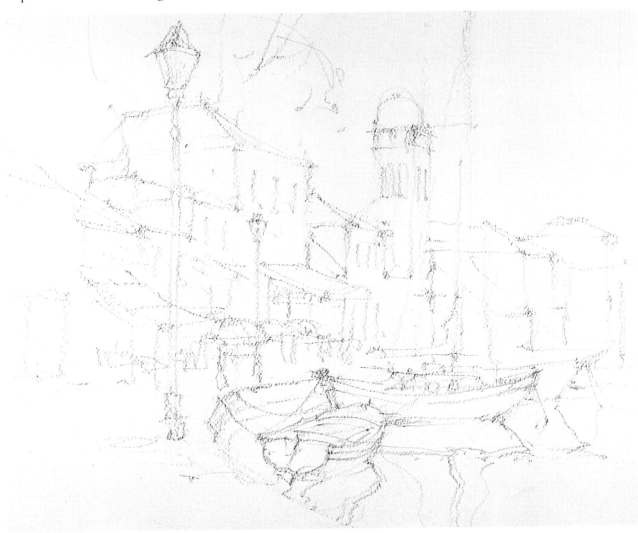

STEP 3 Carve Out Whites

Beginning at top center, lay in a warm gray mixture of Manganese Blue, Raw Sienna and Permanent Rose warmed with Cadmium Orange. Vary the hue each time you recharge your brush. Leave lots of white for masts, tree trunks and sparkle. You can always tone them down later! When you've reached the right edge, begin again at center and work your way left. Develop the shadow mass of the buildings, moving from left to right.

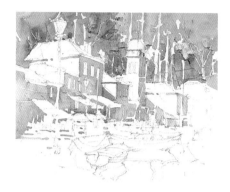

A CLOSER LOOK

5. Add Cadmium Orange and Burnt Sienna for stronger value.

1. Begin here and work to the right. Scratch in branches as you go.

2. Work in a green of Manganese Blue and Raw Sienna.

3. Permanent Rose and Manganese Blue for distance.

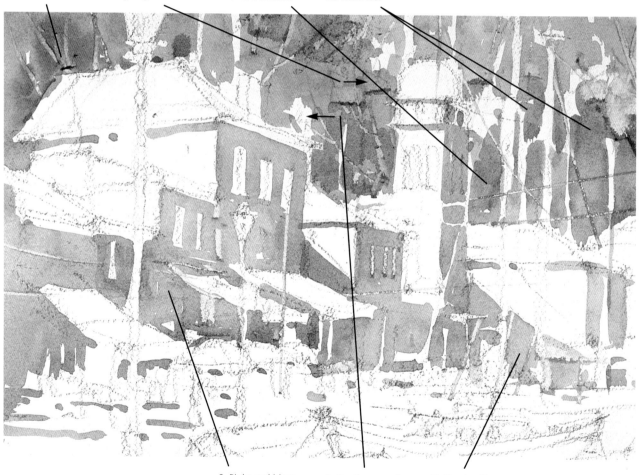

6. Pinks and blues predominate in buildings.

4. Continue wash from here, moving left.

7. Shade off to lighter values in middle distance.

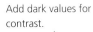 Develop the Point of Interest

A CLOSER LOOK

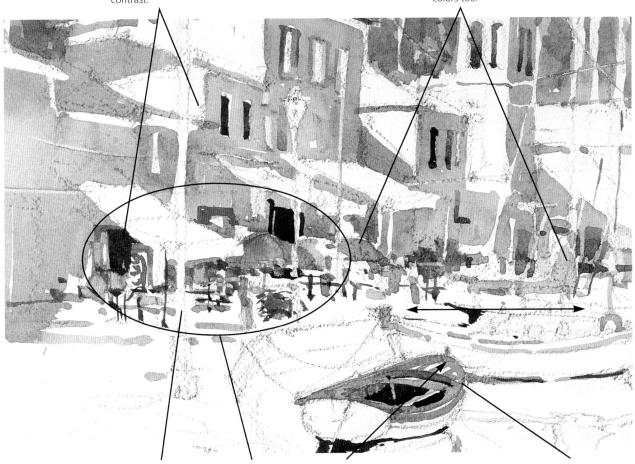

Add dark values for contrast.

Move this blue around the painting. Do that with other colors too.

The whites you carve out are very important! Be sure to leave more than you think you'll need.

Begin to develop the point of interest.

Use your boats as dynamic pointing shapes.

Using Cobalt Blue and Permanent Rose, add a contrasting accent stripe.

STEP 5 Develop the Composition

Keep color and value contrasts subtle towards edges.

Vary colors and values in the next largest masses— the roofs.

Tone one building with salmon for variety.

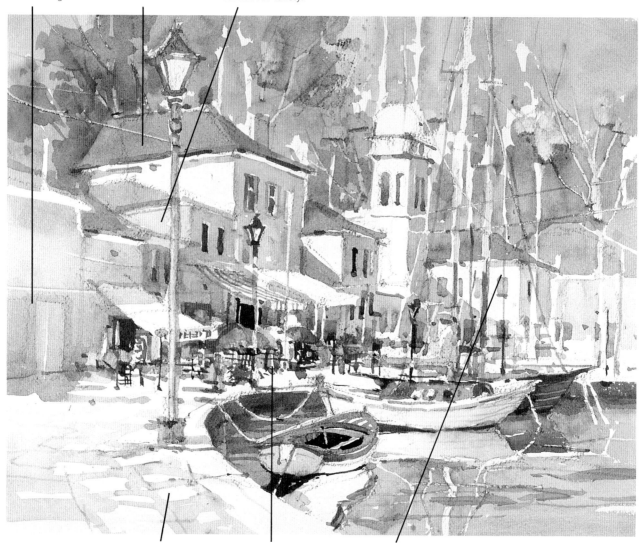

High-key wash of Permanent Rose and Cadmium Orange keeps promenade bright and sun-drenched.

Suggest people, tables, chairs and umbrellas in the point of interest. Don't get hung up on detail! Just shapes and values, not objects. Keep colors brightest and contrasts strongest in the point of interest.

Paint masts dark against white, light against dark.

STEP 6 Complete the Painting

Emphasize the light and sparkle in this scene by fine-tuning values and detail. Glazing some of the dazzlingly white elements to a light value of yellow, pink or blue focuses attention on the remaining whites, which are primarily in and around the point of interest. Elements in the point of interest should be bright and full of contrast, yet devoid of the kind of detail that traps the eye.

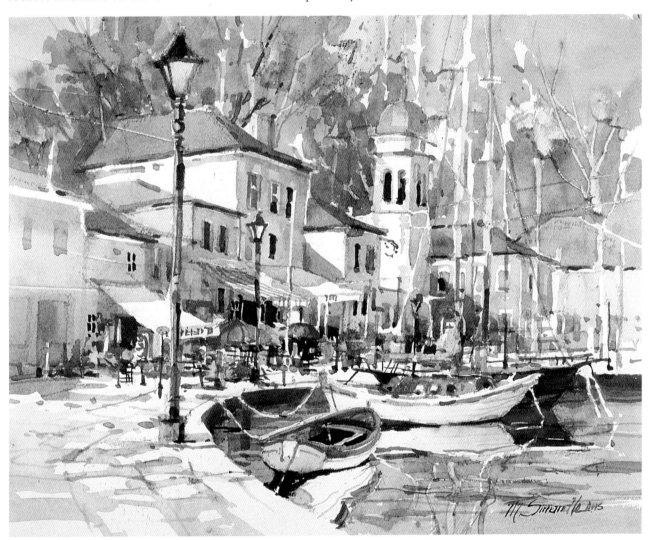

PORT SUNLIGHT, 14" X 18"

Make Your Focal Point Exciting

While harmonies are evident around the point of interest, diversity should be dominant within the point of interest. Look for contrast in value (light versus dark), shape (large against small), chroma (bright color against grayed color), and hue (complementary and near-complementary colors).

A CLOSER LOOK

Just a hint of suggestive detail near the edge.

Intersperse fragments of bright color with darks and whites for interest and excitement.

Strong value contrasts.

Just a few calligraphic elements in the foreground.

Bright orange and yellow colors in a larger element grab the eye.

This shadow mass marks the right edge of the point of interest.

SIMANDLE GRAY

Throughout this book, in every one of my paintings, you'll see me using a triad of colors to create the interesting grays that fill my shadows. Students in my workshops are so familiar with this that they refer to it as "Simandle Gray."

Why are grays so important? Grays are areas of rest for the eye. (It needs a break from all those bright colors and contrasting values in the point of interest.) Grays create quiet spaces. They're also excellent ways to connect your shapes.

Though the ingredients may vary, I usually begin my grays with a mix of Permanent Rose, Raw Sienna and Manganese Blue—three highly transparent, vibrant colors that combine to give me a whole range of mid-value grays. I've dragged out a strip of this triad at left so you can see the world of colors emerging from just these three hues. Triadic grays are the perfect foil for the high-chroma colors used in your point of interest.

What makes these grays so exciting is the ease with which you can vary them by adding a touch of new color to the wash each time you recharge your brush. Lighten and cool for distance; warm and darken in the foreground. The new colors you add don't even have to be from the original triad!

Even more exciting is the subtle range of colors throughout your grays. No dull, monochromatic grays here!

For deeper-value triadic grays, try substituting Antwerp Blue or Cobalt Blue for the Manganese Blue. Warmer grays result if you use Cadmium Orange instead of Raw Sienna.

Experiment with triadic grays until you feel comfortable mixing them. Explore different triads. They'll soon become a welcome addition to your painting repertoire.

Begin with a triad of Permanent Rose, Raw Sienna and Manganese Blue.

Blend full strength for a stormy gray. . . with hints of violet. . . or green.

Dilute for middle-value warm and cool grays.

The granular quality of Manganese Blue adds character.

Dilute again for another whole range of high-key grays.

Substitute Cadmium Orange for Raw Sienna to reach a warmer range of grays.

Take It Outdoors

Working outside has its own special joys; it is by far the best way to paint. Even if you choose to set up in your own back yard, painting on location near home is not that different from painting halfway around the world. It's just that you can usually bring more stuff when it only involves getting in and out of the family car! Still, a little planning goes a long way.

YOUR WORK KIT

Assemble a convenient work kit with as little stuff as possible. Portable easels are great, but a lightweight folding chair and a couple of empty cartons for your painting board, palette and water to rest on works too. You never want your paper to be in full, glaring sunlight, so an umbrella of some sort (preferably opaque or white) is a good investment for those occasions when the sun is behind you as you look at your scene. You may be able to find one that clamps to your chair or easel; I like the type of artist's umbrella that has a telescoping pole you can poke into the ground. Lighten your load by taking only the supplies you need: a sheet or two of stretched paper, sketchbook, paints, palette, brushes, a jug of water, and miscellany such as tissues, pencils, insect repellent, etc.

Your travel painting equipment might be as basic as a sketchbook, a self-contained watercolor paint kit with brushes and a palette, and a water container. A step up from this basic kit is a smaller-size portable folding easel; a dozen or so tubes of paint; a palette; a few brushes; a small pad or block of watercolor paper; and a plastic container with a tight lid that holds sufficient water. That's what I carry, and it all fits into a handy backpack. Create your own work kit, then try it out at home before you go.

DRESS FOR THE WEATHER

Painting's no fun if you're uncomfortable. Layers are best on days when chilly mornings are apt to turn into warm afternoons, and a hat or visor with a brim keeps sky glare out of your eyes. Don't wear sunglasses unless you must, because they distort your color perception and make the shadows fill in. Do take precautions to avoid sunburn, however.

GET AN EARLY START

Get out there early. The best time to paint is the morning, when shadows are long and interesting, the air is fresh and so are you. The bugs are still sleeping, as are most of your spectators. Bring coffee if you like, but you might fare better with a granola bar if rest room facilities are distant.

CHOOSE A COMFORTABLE LOCATION

If you'd rather not have an audience, choose your location accordingly. Although you get used to spectators after you've been painting outdoors awhile, I often wear my Walkman, because the headphones furnish a good excuse to ignore people who would otherwise insist on talking to me while I work. If you don't feel personally secure in a location, find someplace more public—or completely private.

LIMIT YOUR SUBJECT

With the whole world right there in front of you, the temptation is to try to paint it all. My advice, in a word, is simplify. Pick a limited subject, and stay with that. Bring a camera to record the scene for a later, perhaps more detailed, painting.

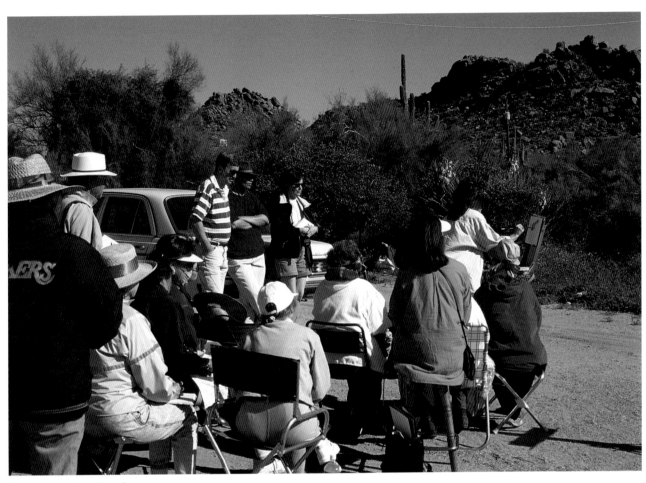

Demonstrating Outdoors
Talk about having an audience! Here I am in the desert, demonstrating for my Scottsdale Artists' School workshop.

WHERE'S THAT BRUSH?

If you know how many brushes you have with you, you'll know to look for the one that fell down in the grass.

Paint on Location

Although it is customary to carry a camera when traveling, nothing compares to making a quick little painting on the spot. Months or years later, you might be lucky to remember where you took a snapshot. On the other hand, the scene captured in your watercolor sketch remains fresh in your memory for a lifetime.

The simple, direct paintings I do on location take less than half an hour each. They have the freshness characteristic of quick, loose, on-location work. Such scenes painted outdoors, directly from observation, can spark ideas and serve as wonderful references for larger studio paintings. I prop them up beside my easel, along with a few of the many hundreds of photos I bring back from trips. The photos may give me facts, but it is these little sketches that convey the memory of the moment and the joy of the light.

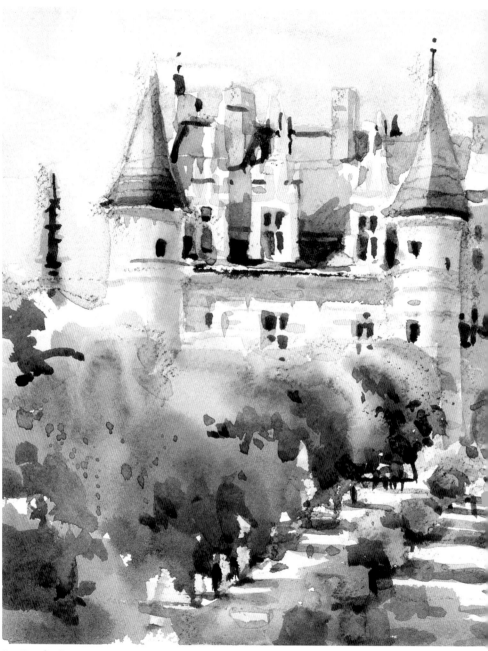

In Castle Country
Ted and I made it a point to paint every day while traveling in France recently. There was certainly no shortage of subjects! Here I am in Amboise, in the Loire Valley—castle country. I set up my easel at the highest spot I could find, far from the crowd. The tourists managed to find me anyway. Wherever I painted suddenly became their favorite spot to take pictures! The finished painting is shown above.

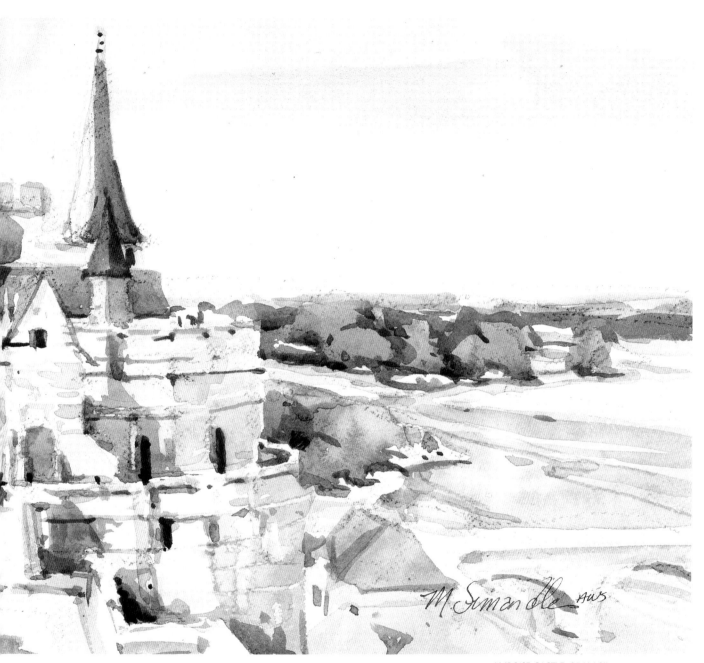

AMBOISE CASTLE, 8" X 16"

Think Positively, Paint Negatively!

Use the following demonstration as an exercise in negative space painting to capture the light that gives great watercolor its characteristic glow. Negative space in an artwork is the area unoccupied by subject matter and utilized by the artist as part of the design.

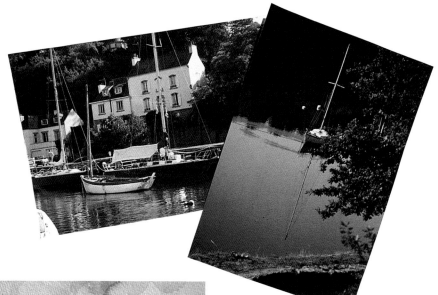

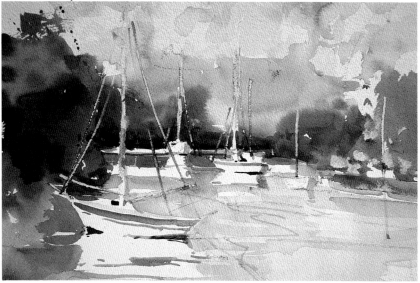

FRENCH HARBOR, 9" X 12"

Evoke the Moment

Here are a couple of photos from Pont Aven, along with some on-location paintings. I want to recapture the light, the look, and the moments I remember so well. A peaceful shoreline, calm water, light coming in over the shoulder of the sturdy whitewashed house, boats at anchor—all evoke the mood of the moment. My original watercolor sketches recall the light.

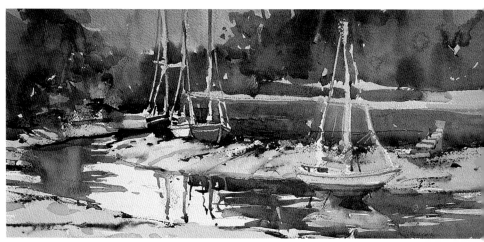

PONT AVEN HARBOR, 8" X 16"

STEP ① Plan the Painting

Plan the painting with quick thumbnail sketches to determine shadow masses, point of interest and composition. This value sketch establishes the house and boat at left as the point of interest; the moored sailboat at right is a secondary point of interest.

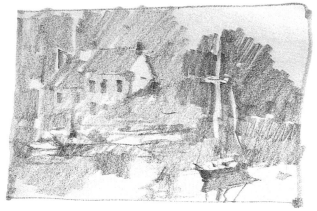

STEP ② Lay in the Dominant Mass

Plan your approach further as you transfer the sketch to your watercolor paper. Begin laying in the dominant background mass by painting negatively around each object, framing the shoreline, house and sailboat mast.

Begin here with a muted green mixture of Antwerp Blue and Burnt Sienna with a touch of Permanent Rose.

Carry the wash left to create the negative shape of house.

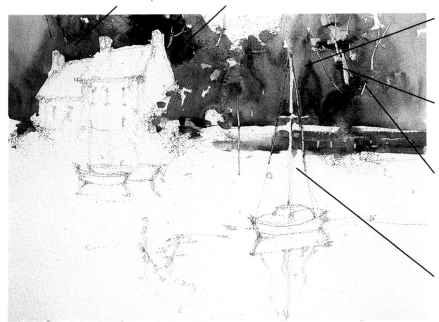

Carry the wash right, varying the green with Raw Sienna and Permanent Rose to warm it.

Build up background values while still wet. Scratch in distant trees.

Sap Green warms the wash here. Antwerp Blue and Raw Sienna for an even warmer green shoreline.

Scratch rigging into wet paint, moving pigment downward into white.

STEP 3 Glaze in Secondary Masses

Continue to paint negatively around the moored boats, glazing in the water areas. The outlines of the house and boats are already well defined at this stage.

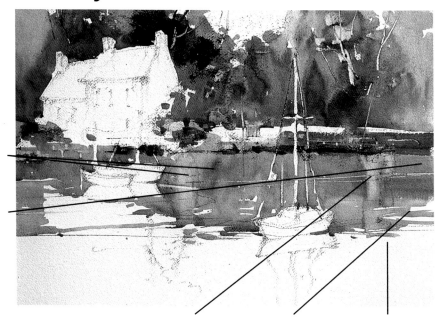

Permanent Rose and Raw Sienna in the wash add light to the reflection.

Begin a wash of Antwerp Blue and Burnt Sienna at this edge, varying it as you go to match the background being reflected.

Scratched horizontal lines help create the water surface.

Horizontal white areas begin to create reflected ripples.

Break up the wash along its bottom edge.

STEP 4 Begin Painting Objects

Begin painting the house and boats, using washes already in place to help determine their values. Glaze darker values in water and background as you see how they relate to the house and boats just painted.

The background tells you how dark the roof should be.

A mixture of Cobalt Blue and Permanent Rose for soft shadows on the house.

Create reflection using the same wash as on the house, but darken it just a bit.

Keep reflections directly below the objects they reflect.

Glaze to adjust values.

Permanent Rose adds light and life around the house.

Reflection suggests movement of water.

DEMONSTRATION STEP 5 Spark the Light

Complete the painting by adjusting values to work well together. Deepen values in the water using horizontal brushstrokes to imply watery reflections and movement. Glaze darker details on boats, house and distant trees for greater contrast. Add spots of broken color for sparkle and life. Add a few fine lines of calligraphy with a rigger brush, and the painting is finished. Though the details are from photo references, the colors, mood and light are from the little on-location paintings that captured the memories of our visit to France.

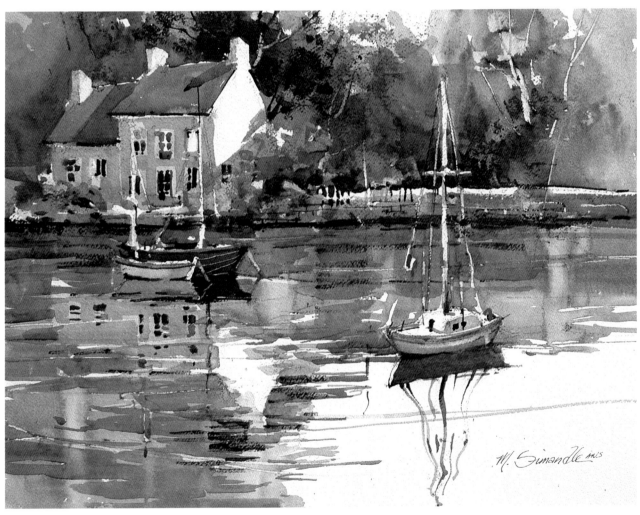

PONT AVEN, 14" X 18"

Work on Site

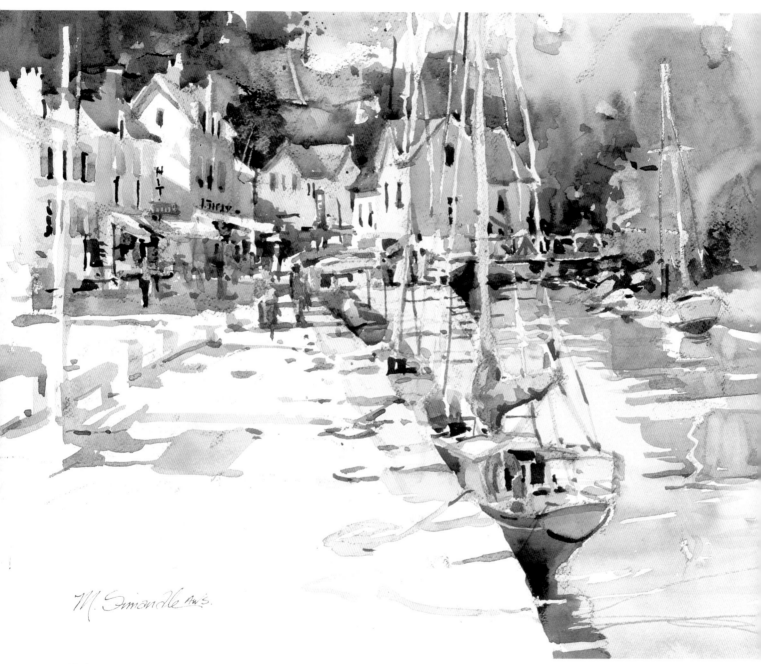

PONT AVEN HARBOR, 12" X 16"

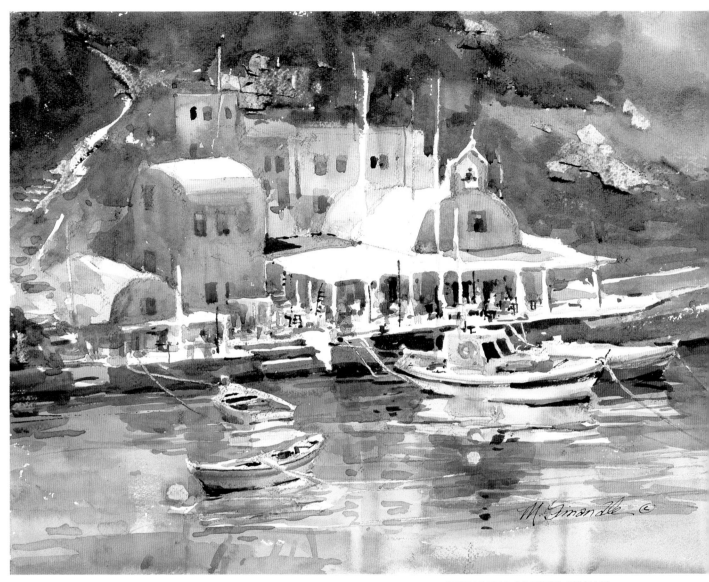

On Location
I did this little painting while comfortably seated on a hillside overlooking Oia Harbor, in Santorini, Greece.

Find Inspiration in the Commonplace

If you ever throw up your hands in frustration and complain, "I can't find anything here to paint," remember: Finding the perfect scene isn't really necessary. The artist's job is to take the imperfect and perfect it!

Finding a good subject to paint can be as simple as taking a new look at the things you see every day: a bowl of fruit, a plate of cookies and a glass of milk, the corner of a sunny or shadowed room, a selection of favorite antiques, dishes in the sink, laundry in a basket, the top of your work table, a simple front porch. Become accustomed to painting these kinds of everyday subjects: You'll soon become aware of the beauty and light all around you.

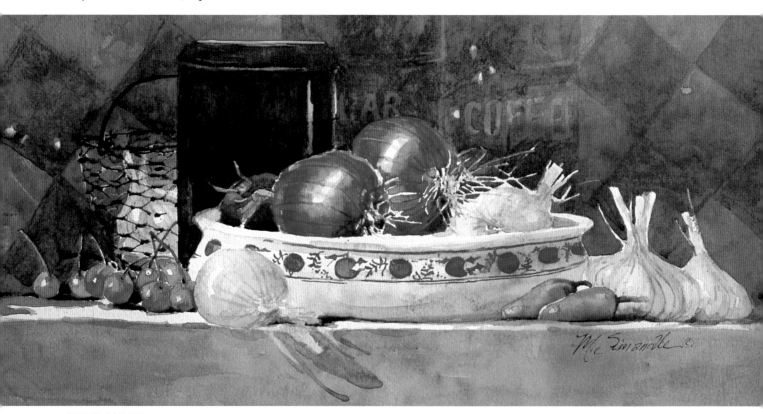

ONIONS, 8" X 16"

Everyday Impressions

LIGHT AND SHADOW

There is nothing extraordinary here, yet more than enough to inspire a painting. This house sparkles in the sunlight, which creates intriguing shadow patterns. It also has that wonderful flowering shrub out front.

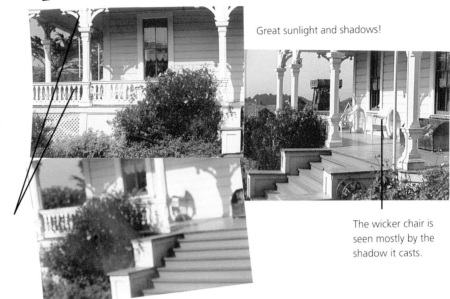

Great sunlight and shadows!

Ornate Victorian details.

The wicker chair is seen mostly by the shadow it casts.

STEP 1 Plan Your Composition

Take lots of liberties with your composition, rearranging elements and planning shadow patterns with thumbnail sketches. They're the quickest way to decide on a viewpoint, what to include, what to omit, how to deal with shadows, background and so on. My final sketch includes sunlight flooding in from upper left creating shadows that slant down to the right and results in an interesting triangular shadow shape at top right. The complex, colorful point of interest will be in the sunlit area to the left. Brilliant, simple whites and low-key shadow areas will contrast at right. Planning at this stage pays off in a big way later on.

STEP 2 Lay the Foundation

A fairly careful drawing on your
watercolor sheet affords a first
look at the full-sized composition.
This is your best opportunity to
adjust sizes, proportions, etc.

STEP 3 Punch Up the Point of Interest

Let's begin right at the point of interest. Lay in bright color and work out from there. The large shadow mass at upper right establishes the dark value.

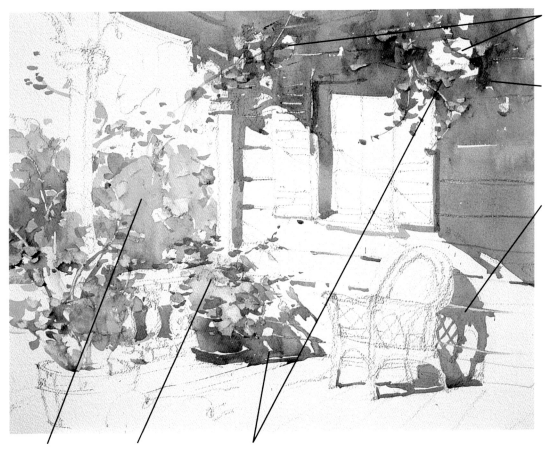

Leave ample white for sparkle.

Build shadow shape with Manganese Blue, Raw Sienna and Permanent Rose. Keep varying it —greenish around hanging plants, warmer as you move along.

The chair is defined by its shadows.

Big shapes first; Permanent Rose plus Manganese Blue dropped in wet. Scratch in lines.

Lay in Manganese Blue with a touch of Permanent Rose for a soft lavender hue.

Mix Manganese Blue, Raw Sienna and a little Permanent Rose to create muted greens. Lay that in wet so it blends with shadow hue.

STEP 4 Build Value and Color

It's time to start glazing in deeper values, brighter colors, highlights and accents.

Build flower shadows with Cobalt Blue, then move that color around the painting.

Begin painting negative background space around flowers.

Cobalt Blue and Permanent Rose for shutters. Use that hue elsewhere too!

Suggest tree reflections with Burnt Sienna and Antwerp Blue.

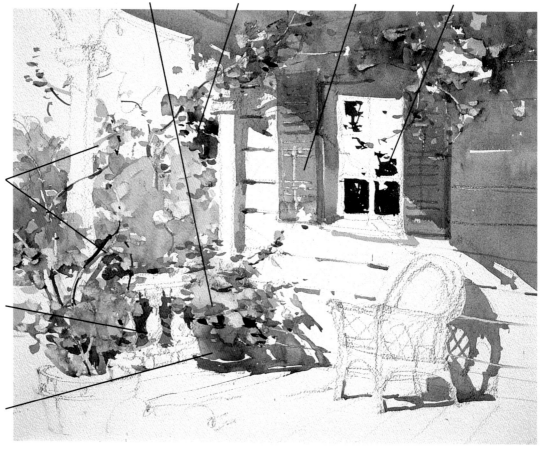

Define calligraphic stem and vine details with a rigger brush or palette knife.

Carve in shadows with Raw Sienna and Antwerp Blue, adding depth to foliage and creating negative spaces between balustrades.

Burnt Sienna shadowed with Antwerp Blue creates the rounded pot.

STEP 5 Lay in the Background

The painting takes on depth and dimension as you paint in the negative areas of the background.

A CLOSER LOOK

Lighten green for airy distance by adding Raw Sienna and Cadmium Yellow to the mixture.

Define the post with background color.

Cool the green with Cobalt Blue for distance.

Begin darkest green (Antwerp Blue with Raw Sienna) here and work left.

Work dark greens around and into pinks. Poke "holes" in the flower mass as you do.

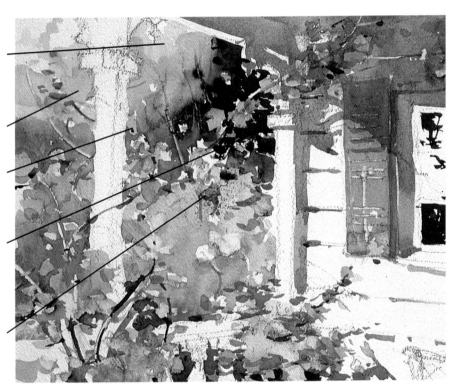

STEP 6 Balance Colors and Values

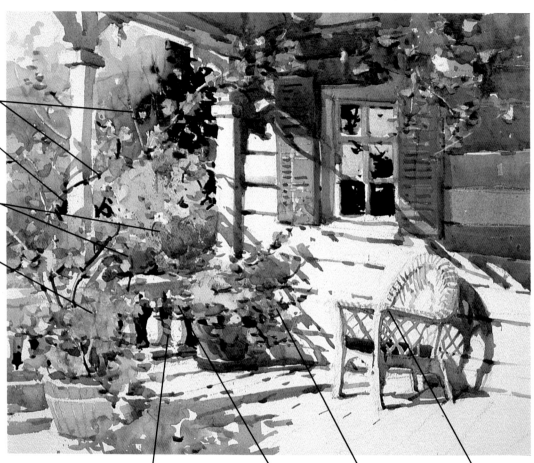

Add more stems and vines for interest.

Dark accents make background recede, move post forward.

Continue glazing to enrich colors and build texture.

Continue to enrich flower and foliage hues.

See how shadows shape the balustrades.

Create shadows using my familiar gray mix: Raw Sienna, Permanent Rose and Manganese Blue.

Bright accents of Cadmium Orange.

Add minimal wicker details with warm grays.

Add Finishing Touches

Step back and look at your painting for a day or so, separating yourself from your involvement with creating it. Return later with a fresh viewpoint to adjust shadow values and add a few more spots of color. As you can see, exciting subject matter can be found around your own house. Don't waste your precious painting time looking for the perfect subject. Take the commonplace and make it exceptional through your painting!

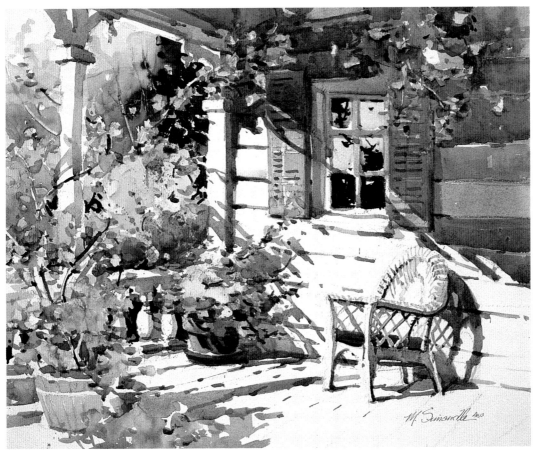

PORCH SHADOWS, 14" X 18"

Notice Subtle Scenes

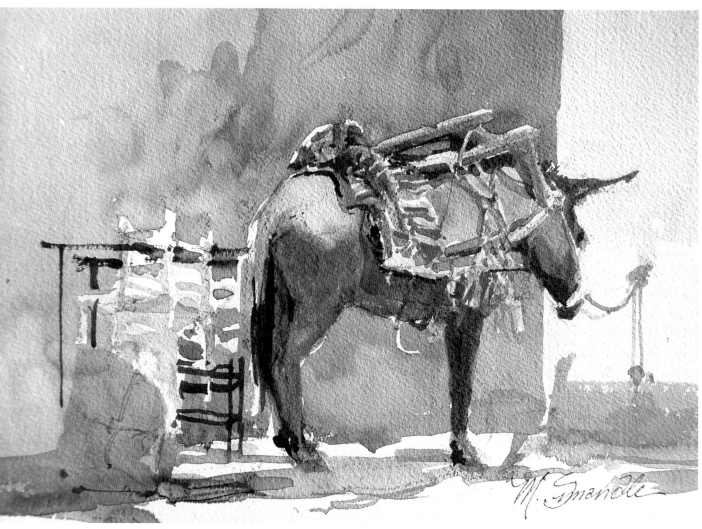

GREEK DONKEY, 12" X 16"

Focusing on Little Scenes
When traveling, don't become so
focused on grand scenes that you pass
by charming little ones, like this placid
donkey.

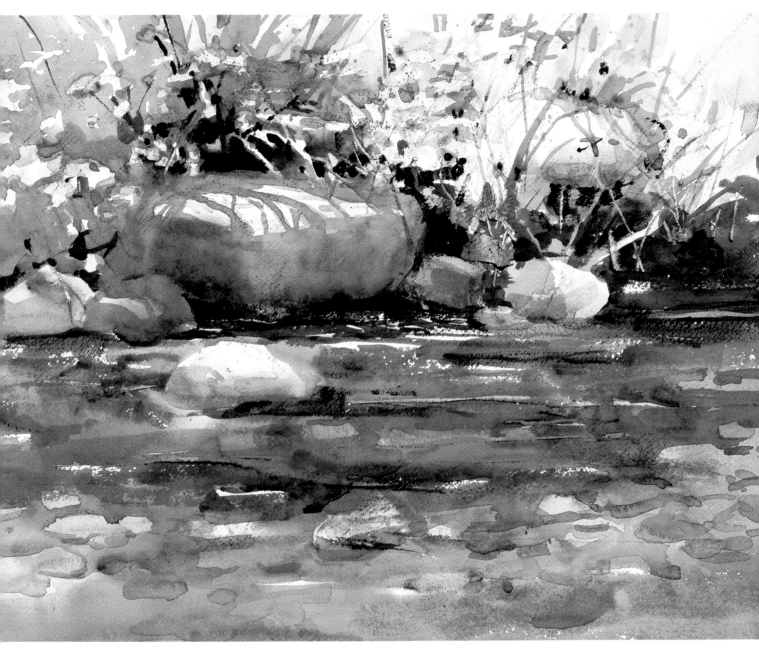

Simple Yet Challenging
This simple subject presents a challenge
in portraying sun-dappled water
beneath overhanging branches.

SIERRA STREAM, 12" X 16"

Cityscapes That Sparkle With Light

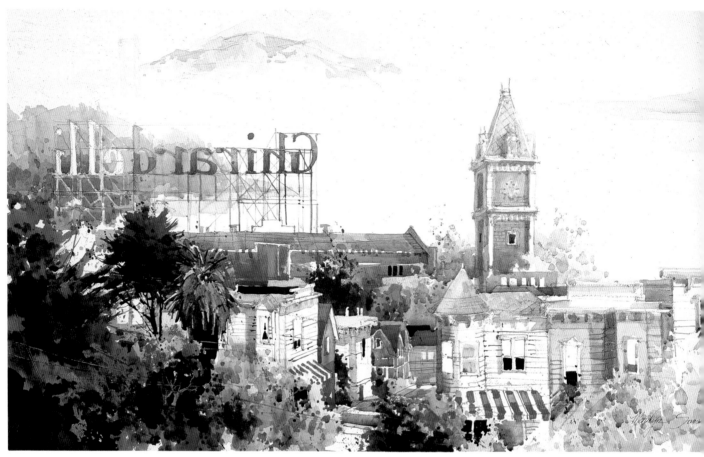

GHIRARDELLI, 24″ X 36″

City Contrasts

The reversed lettering of the familiar sign is what first attracted me to this scene. Bold lettering in a painting can sometimes be a disturbing distraction. Reversal helps reduce these letters to abstract shapes. Did you notice the contrast of dark lettering against light sky, light lettering against the darker clouds? In addition, I've contrasted the busyness of the street scene and buildings in the lower half of this painting against an understated sky.

You want your paintings to be lively no matter what you paint, and cityscapes demonstrate the techniques I use to put life into any subject. The way I see it, a city scene should look alive with people and movement. You should almost be able to hear the honking horns, the hurrying footsteps, the roar of traffic and even, in the following demonstration, the clang of the cable cars. The challenge in a cityscape is to make busy look simple!

Sunlit Street Scene

An Ordinary Scene

Here's a nothing-special snapshot I brought back from a trip to San Francisco, one of my favorite cities, just a few years ago. Paint along with me as we bring this street scene to life.

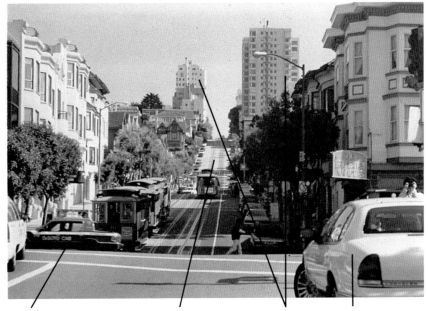

This car obstructs the view. Omit it.

Emphasize the steepness of the hill.

Too much sky and background detail.

This car is not needed.

Cropping

The snapshot is full of distracting and irrelevant detail. The first task: Simplify! Start by eliminating whatever doesn't enhance the subject. The easiest way to begin is to crop the four sides, perhaps using four other overturned snapshots. Keep evaluating until you've distilled your subject right down to its essence. Here's that same snapshot, cropped to eliminate unnecessary detail.

STEP 1 Plan Your Composition

Now's the time to experiment. Should the cable car be in the shade? Should the street be in partial sunlight or mostly shadowed? Notice the patterns of light and dark values in the different thumbnails. Which do you think works best? Now is also a good time to work out details of such elements as the cable car and the "Buena Vista" sign. As you work out value patterns and further develop the composition, you'll become more and more familiar with your subject.

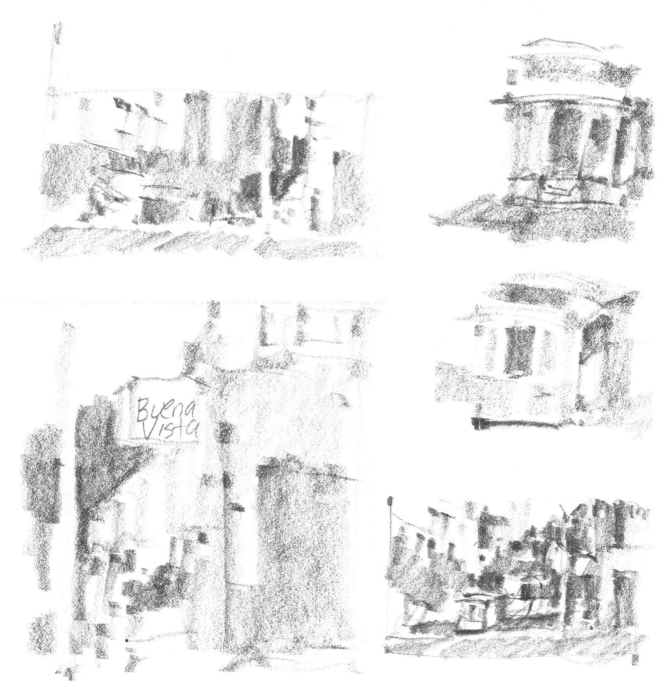

Make a Careful Drawing

Tie these trees together as a single element.

Sun will highlight this side of the cable car.

Cable car tracks in shadow show as streaks of light.

Emphasize—even exaggerate—the hill, leaving just a patch of sky showing.

Light comes from this side.

Not cars . . . just shapes!

These lines lead the viewer into the painting.

Lay in Your Largest Mass First

With strong sunlight entering from the right, the largest mass, the shadow, is the one that establishes the composition. Here you can readily see connected shadow shapes.

Begin your wash here with a cool gray, working downwards, warming it as you go.

Flying flags add a splash of color.

Work in greens for tree shapes.

Start creating vertical masses.

Preserve lots of whites for sparkle.

Scratch in tracks, power lines, etc., while washes are moist.

Warm the gray of the foreground with Permanent Rose.

STEP 4 Create Secondary Masses

The left side of the street—trees, sunlit buildings and such—will form the next largest mass. Get that down, then move on to cable cars and the rest.

Dark values, used sparingly, move the eye left.

Begin secondary wash here, and work to the fore-ground.

Glaze to darken values in the shadows.

This large sunlit wash contrasts with shadow mass.

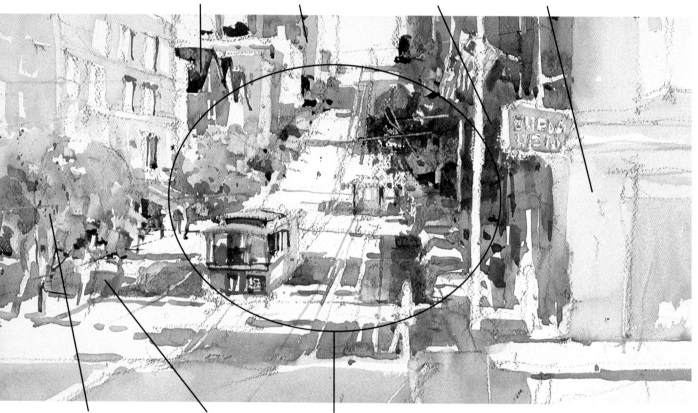

These greens are based on Manganese Blue and Raw Sienna.

Shadow extended out to left.

Develop the point of interest.

Bring the Painting to Life With Final Touches

The final details bring this painting to life. Glaze in smaller shapes to break up the larger masses, for example, in the sunlit building at far right. Look into the large shadow mass, where values have been fragmented and deepened to increase contrast.

Notice how little detail is needed to tell you that these are parked cars. A little detail goes a long way. Suggest people, cars, trees, buildings, etc.

Finishing touches include scratched-in power lines (laid in with a rigger brush); tracks; people; a little spattered color and lots of broken color (see page 84) around and in the point of interest. Look at all the bright touches of reds and yellows.

Finally, stand back and look at your painting. If some whites are too bright, glaze them down a bit.

I like to turn my painting upside down at this point, so it becomes abstract. I evaluate that abstract design and adjust it accordingly, often while it's still in the inverted position.

Another way to objectively view your painting is to put it aside for a day before signing off on it. That time away affords you a fresh view of the piece when you return.

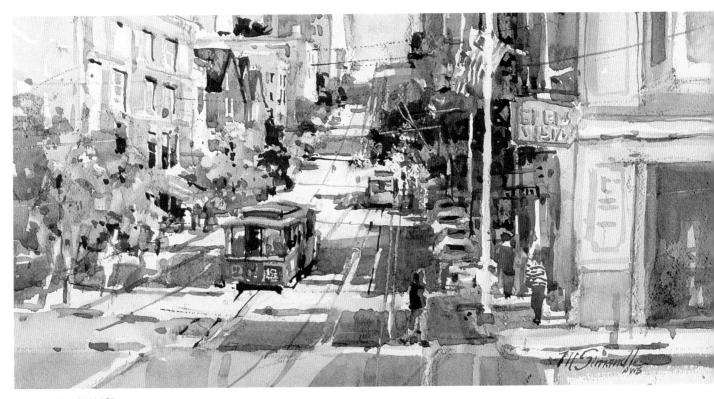

BUENA VISTA, 8" X 16"

What Is "Broken Color"?

A large part of what adds light and life to my paintings is what I call broken color — many, many fragments of bright pigment, sparkling and contrasting with the white of the paper. The eye dances over these bits of color, enjoying harmonies, contrasts and edges; seeing detail, perhaps where none truly exists; taking pleasure in the feeling of light and movement. When your eye sees a color, it unconsciously seeks out other instances of that same color.

Because broken color attracts and delights the eye, it works best in and around the point of interest. Often it helps create the point of interest.

You'll find passages of broken color in just about every one of my paintings. Take a look at *S.F. Orient* on the right. This view of San Francisco's Chinatown is a riot of broken color, with rhythmic patterns inviting the viewer to explore, creating light, sparkle and interest.

To experience firsthand how you can use broken color to bring the point of interest to life, grab your brush and we'll develop a Portuguese street scene in the next demonstration.

SIMPLIFY!

Street scenes can easily become too complex. Try squinting at your subject to blur out detail so you see only the large shapes. Then paint the shapes you see, breaking them up afterwards for color and interest.

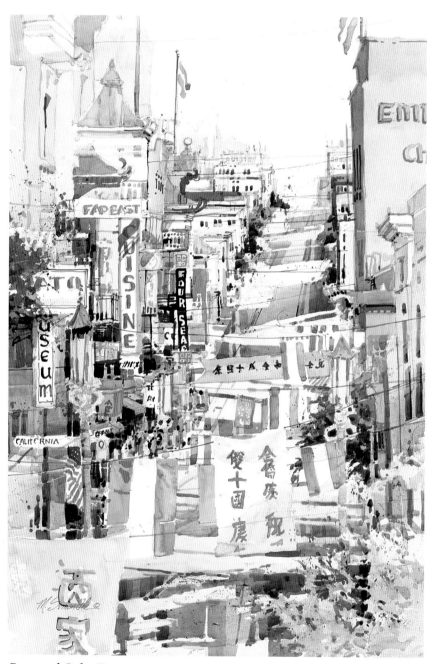

Repeated Color Patterns
The rhythmic lines, shapes and patterns of cityscapes create exciting eye movement. The composition of *S. F. Orient* is full of pattern and broken color. Even lettering, readable or not, creates pattern.

S.F. ORIENT, 36" X 24"
Winner of the American Watercolor Society 1994 High Winds Medal

Light and Mood

DETAILS, DETAILS

While developing a composition, you'll often spot some detail you want to include. If it doesn't belong in a simple value study, just sketch it off to one side for later reference.

PROFUSION OF DETAIL

A narrow street, a cafe with umbrella-shaded tables, bits of foliage, signs and awnings—a profusion of detail. The key is to pick and choose elements from these two photos to come up with a scene that's more effective than either.

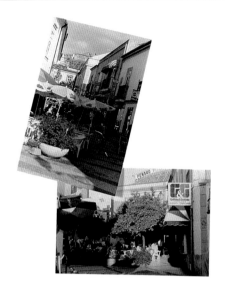

STEP 1 Develop a Composition

USE THUMBNAILS

Explore composition in a series of thumbnails. Should it be horizontal or vertical? How can dark tree masses be used to frame the light? How will the shop signs help create broken color?

MAKE A VALUE SKETCH

My value sketch is simplified to just three values: white, middle and dark. Notice how connecting all the light, all the middle and all the dark values unifies the composition.

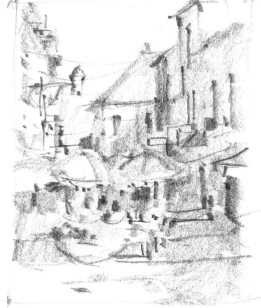

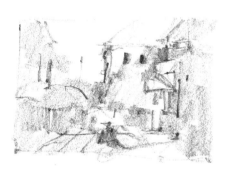

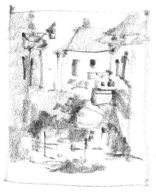

STEP 2 Transfer the Concept to Paper

Keep developing your design as you sketch your composition on watercolor paper. If something isn't working, change it!

Diagonal shadow edges help define the light source.

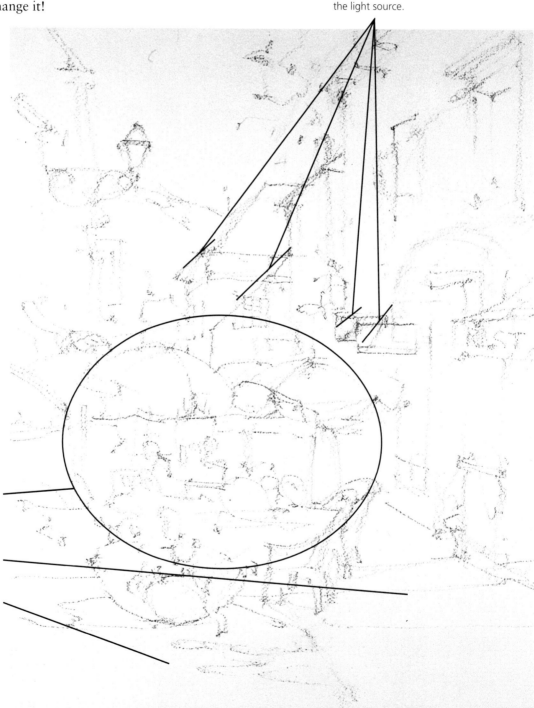

This will be the center of interest.

This will be the shadowed side of the painting.

This will be the high-lighted side.

STEP 3 Establish Light and Mood With First Washes

For important shadow shapes, mix an interesting gray, maybe Burnt Sienna and Antwerp Blue and vary the mix each time you recharge your brush. Connect the shapes as you go, but be sure to leave sparkles of white showing through.

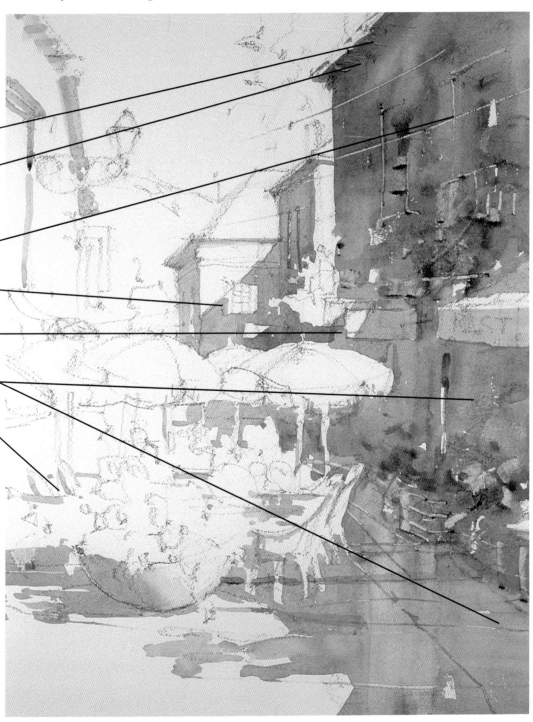

Begin your wash at the top.

Warm it with Cadmium Orange for reflected light under the eaves.

Scratch lines into the wet wash with palette knife tip.

Cool and lighten for distance.

Keep shadow shapes connected.

Warm the wash to bring it forward.

Move the gray around your painting.

STEP 4 Develop Balanced Masses

Use a sunny mix of Cadmium Orange and Raw Sienna for the awnings.

SAVE YOUR WHITES

If you're not yet comfortable with negative-space painting, try this: Paint in the positive shape itself, utilizing a very light wash compatible with the final color. If the negative area has to end up white, paint it with the lightest possible wash. Only you will know it's there. When it's dry, paint around it. I've done that here with very light Cobalt Blue laid into blossom areas of the foreground planter. Those areas will become pale violet later. You'll soon get the hang of negative painting, and you can skip this in-between step.

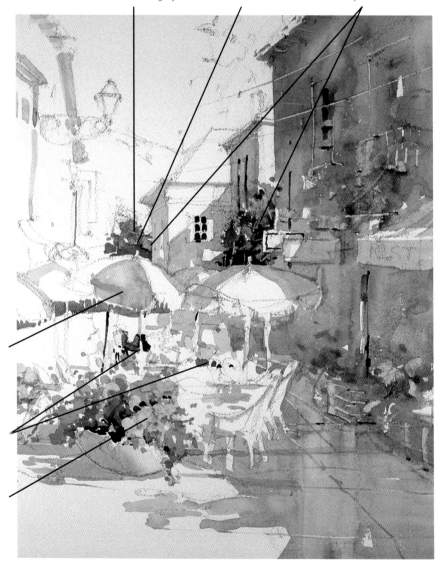

Start building up varied foliage greens: Cobalt Blue with Cadmium Orange, Antwerp Blue with Raw Sienna. Add a touch of Permanent Rose to gray it.

Scrape out wet color.

Keep elements dissimilar in shape and size.

Shadow awnings with a mixture of Cadmium Scarlet, Burnt Sienna and Cadmium Orange.

Begin building color into the point of interest.

Add Light Cobalt Blue in blossom areas of planter.

 # Build Up Color, Break Up Shapes

Glazing is a good way to break up both large shadow shapes and highlight areas. Now you can begin building broken color in the point of interest.

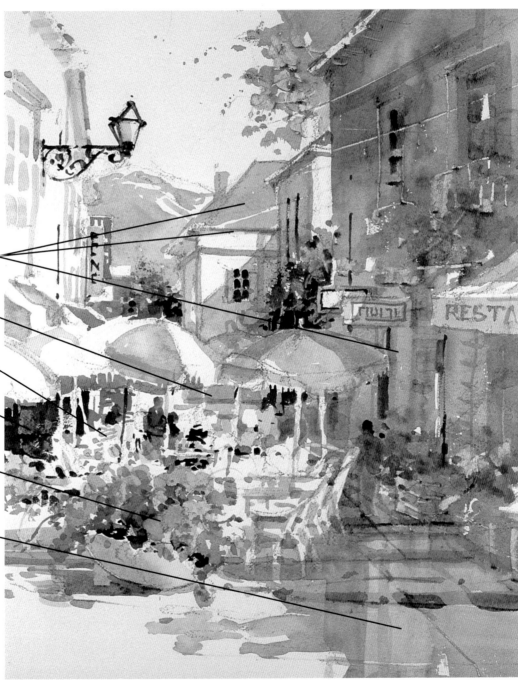

Burnt Sienna and Permanent Rose for roof shapes, broken by "wire" line.

Use Cobalt Blue to glaze in shadow lines and values.

Colorful stripes imply a T-shirt.

Dark shadow balances large shadow mass at right.

Permanent Rose glazed over the light blue.

Darken this wash to emphasize a strong vertical.

STEP 6 Add Finishing Touches

A CLOSER LOOK

Build color and value in and around the point of interest. This is where detail, if any, belongs, but note how little actual detail there really is here! Broken color suggests people, tables, even the happy chatter of voices and clinking of glassware. Now's the time to have some fun with line work. Use your rigger brush for pavement lines, suspended wires, building edges and such, but don't overdo!

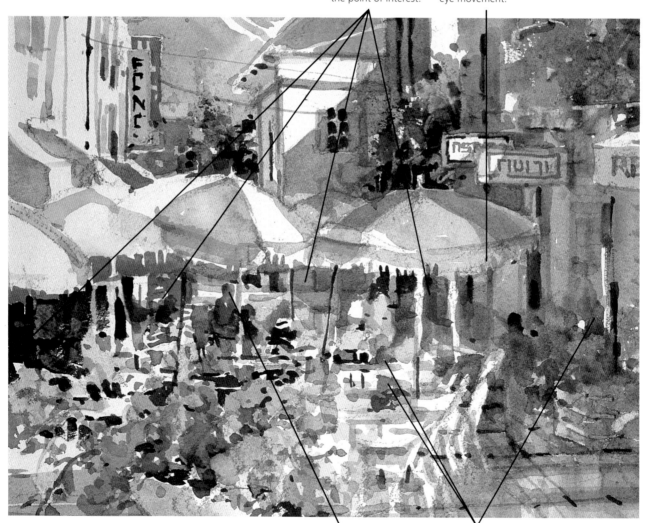

The line of umbrella fringes creates horizontal eye movement.

Dark values frame the point of interest.

Simple shapes suggest figures without defining them.

Spots of pure Permanent Rose are moved around the painting.

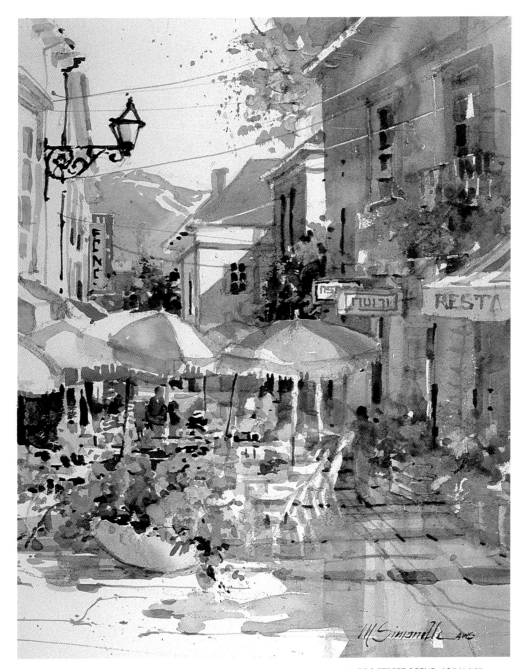

Capturing Light
See how those umbrellas seem to sparkle in the sunlight? To capture light in watercolor, you have to contrast it against adjacent darks. It looks like there's a lot going on in the point of interest, but it's really very simple: broken color, light, shadow and shape.

LAGOS STREET SCENE, 18" X 14"

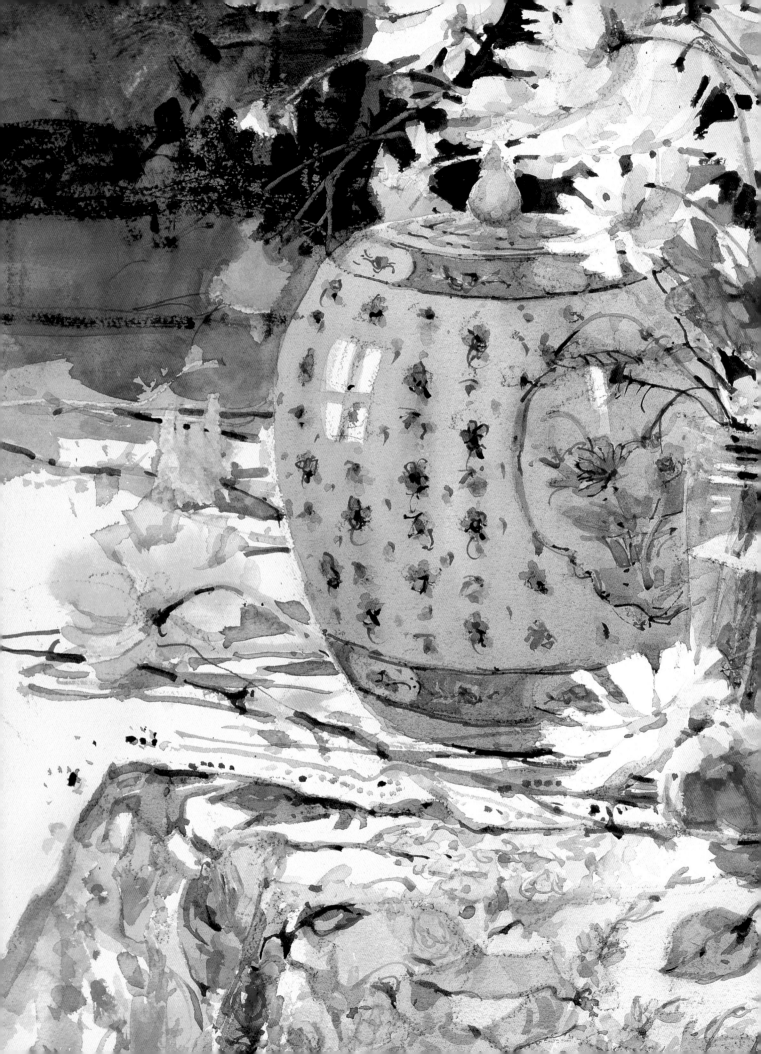

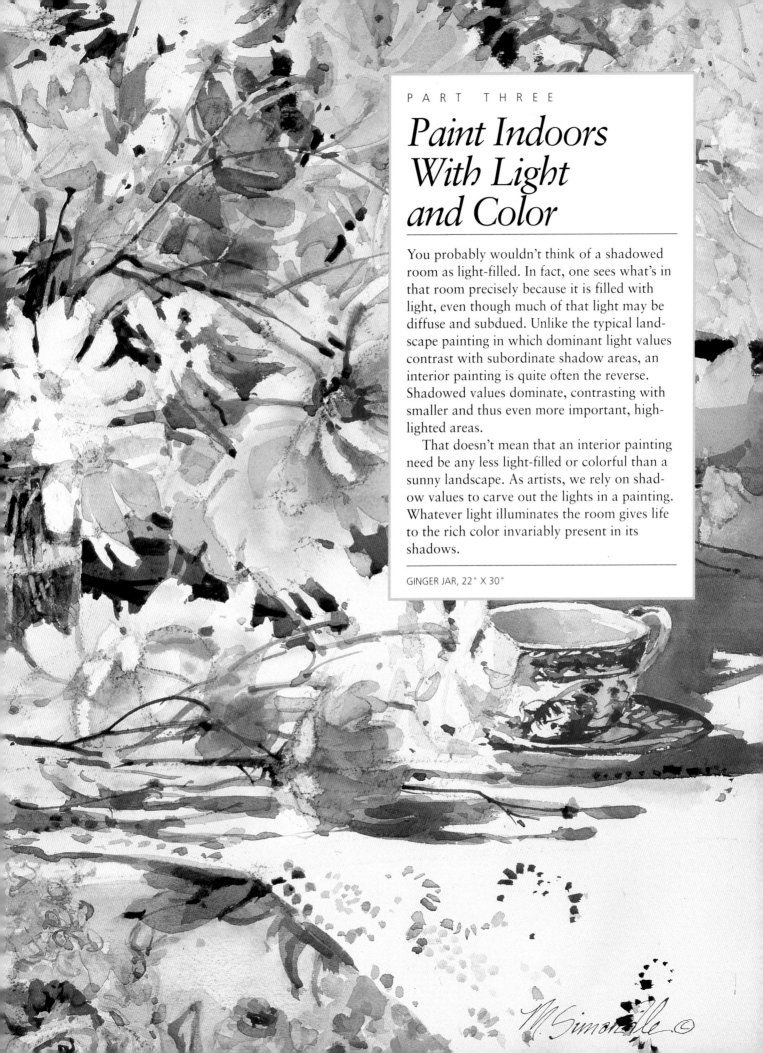

Paint Indoors With Light and Color

You probably wouldn't think of a shadowed room as light-filled. In fact, one sees what's in that room precisely because it is filled with light, even though much of that light may be diffuse and subdued. Unlike the typical landscape painting in which dominant light values contrast with subordinate shadow areas, an interior painting is quite often the reverse. Shadowed values dominate, contrasting with smaller and thus even more important, highlighted areas.

That doesn't mean that an interior painting need be any less light-filled or colorful than a sunny landscape. As artists, we rely on shadow values to carve out the lights in a painting. Whatever light illuminates the room gives life to the rich color invariably present in its shadows.

GINGER JAR, 22" X 30"

Create a Luminous Interior

The limitations of the photographic process invariably cause shadows to appear dark, dense and lifeless. Compare almost any photo to the actual subject. You'll be amazed at how much the camera has lost!

Before you spend time painting from photos, absorb plenty of experience studying — and painting — the real thing! Only then will you know how to replace, re-create and reinvent what your photo reference will inevitably have lost.

MUDDY SHADOWS

See how muddy the shadows appear in these two snapshots? My memory of this room tells me there was plenty of reflected light bouncing around when these photographs were taken. The shadows I saw were filled with color and detail. Let's find that light, and bring it to life!

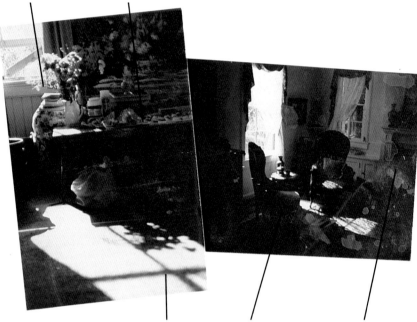

Sunlit flowers on the windowsill. Nice touch!

There's lots of detail and color in these shadows, but the camera has lost them.

Let's work with the brilliance of these exciting light-and-shadow patterns.

On the plus side, all the shadow shapes are nicely connected.

You can hardly see the beautiful bouquet on the table!

DEMONSTRATION STEP 1 Compose the Subject

Whether you're working from photos or sitting right there in the room, begin by editing what you see. Leave out what's irrelevant, distracting, confusing. Experimenting with plenty of thumbnail sketches will help you arrive at the best solution.

Seeing Shadow Shapes and Patterns

Once you have a plan that you think works, try one or more value sketches to confirm your choice, using them to further develop composition, value pattern and details.

An important key to unifying your paintings is knowing how to use shadow shapes to connect the elements. When the major shapes in a painting exist as separate spots, unconnected and unrelated to each other, there is nothing to hold the composition together, and everything falls apart.

Disconnected
Shadow Shapes
In this sketch, the shadow shapes are not connected. There's no point of interest, nothing to hold the composition together, and nothing to keep the viewer's eye in the painting.

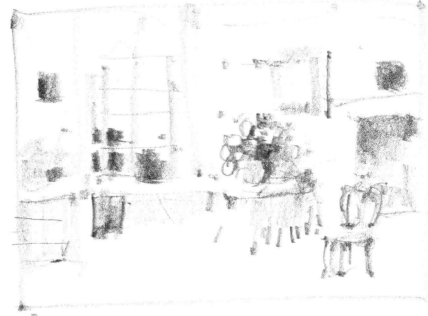

Nicely Connected Shadows
Here the light is centralized. Shadow shapes are large, varied and nicely connected. Now the eye moves easily from one element to the next. The composition is interesting. When you've developed the right approach to thumbnail sketches, they'll help you to see value patterns. Your thumbnails should not be outlines of objects or masses, but roughly-stated value patterns: light, mid-gray and dark.

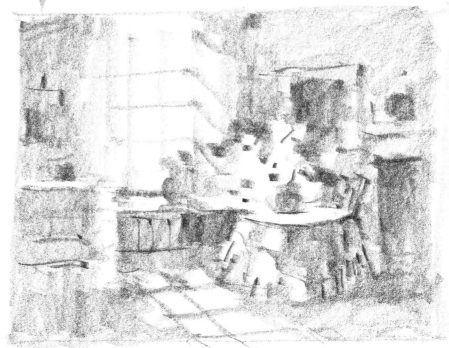

STEP 3 Transfer the Concept to Watercolor Paper

Sketch the largest, most important shapes first: the pattern of light in the window and on the floor, the table with its bouquet. Then develop the shadowed areas to left and right.

STEP 4 Paint Big Shapes First

It's fun to get right to the point of interest, but this time, start with the major shape at top right to establish the dominant shadow value. It will contrast nicely with the brightness and complexity of the floral arrangement. Remember to think shapes and colors, not objects.

A CLOSER LOOK

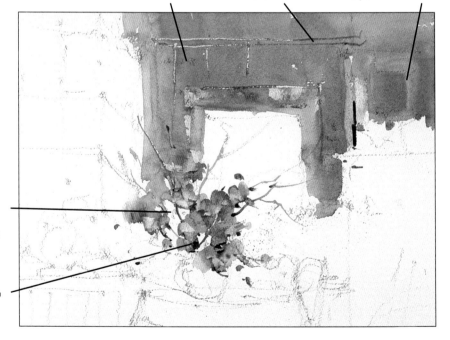

Begin here. Antwerp Blue and Permanent Rose with a touch of Cadmium Orange. Keep it simple, light and colorful!

Flow a little Manganese Blue into the wash.

Wet-in-wet here yields the soft edges you want, outside of the point of interest.

Leave plenty of whites within the floral for light and sparkle. Vary shapes for interest.

Build greens with mixtures of Antwerp Blue, Burnt Sienna and Raw Sienna.

These whites are very important.

With palette knife, scrape and smear the small secondary floral shape before it dries.

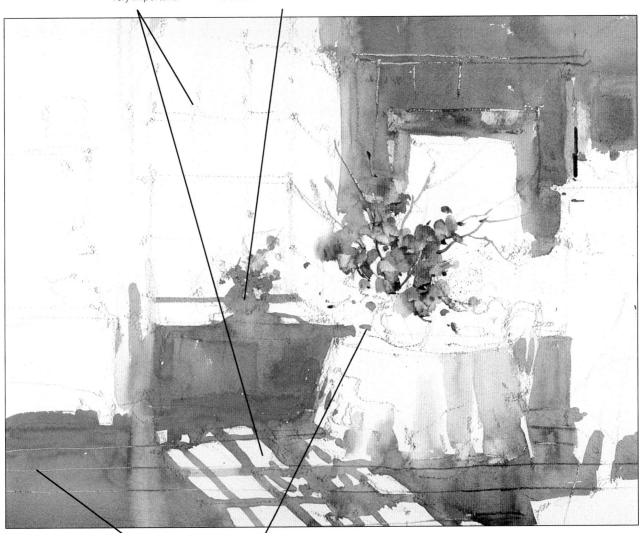

Mixtures of Manganese Blue, Permanent Rose and Scarlet Vermilion for this warm foreground wash.

Ending a wash with a few spots of color enables one's eye to move easily from place to place.

Note how shapes are connected throughout the composition.

STEP 5 Complete First Washes

Begin glazing deeper, richer values into shadow washes. By now, you should be bringing most of your shadow areas to the desired values. Even at this early stage, keep in mind that both diversity (light against dark, textured against smooth, large masses against small) and harmony (pleasing color and value transitions, areas of sameness and rest) are needed to create visual appeal.

Narrow value ranges in shadow areas help focus attention towards the point of interest.

Color changes in window mullions keep them interesting, emphasizing the dazzle of light.

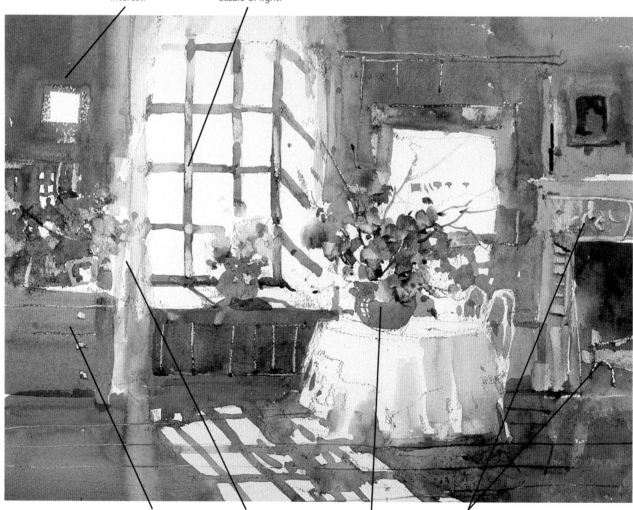

Mix Manganese Blue and Cadmium Orange for a cool green.

Mix Cadmium Yellow and Cadmium Orange for sunlit draperies.

Use Cobalt Blue in the pot, then spot it elsewhere in the painting as well.

Scratch highlights with palette knife into the still-moist wash.

STEP 6 Build Color and Value Contrasts

Continue to glaze texture and detail into the floral.

Here's an opportunity to put in a mini-version of one of your favorite paintings, but keep it subdued and simple!

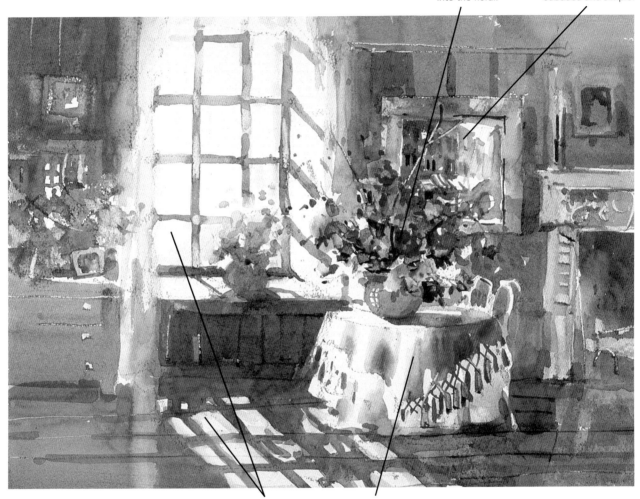

A few light touches of Cadmium Orange soften and warm sunlit surfaces.

Cadmium Red and Burnt Sienna. Note how well this reads as a red tablecloth, even though color is visible only in shadows!

A CLOSER LOOK

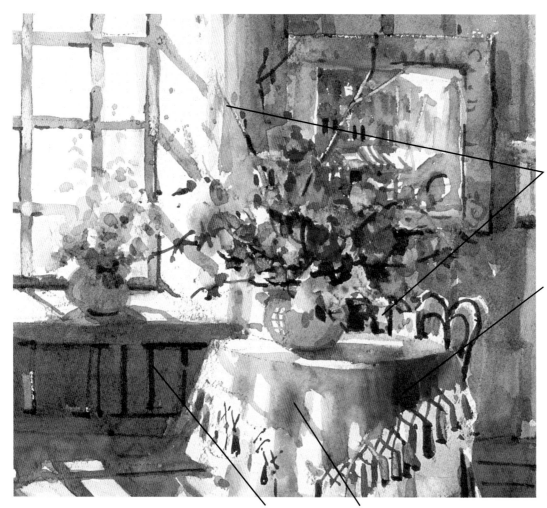

Intriguing color, linear details, and touches of Cadmium Orange and Cadmium Yellow build interest.

Create a deep shadow value with Alizarin Crimson and French Ultramarine Blue.

Small touches of color further break up the large shapes.

Move a little more color around the tablecloth, yet be aware of how little it really needs.

Adjust Values, Finish Details

Were you to compare the finished painting with the snapshots on page 94, and had you not painted along, you might wonder how we got from there to here. How lifeless this painting would have looked had we simply copied those photos. The lesson is clear: Never rely on your photo resources for shadow detail or color. Use your memory or imagination to recreate them for paintings with glowing light, rich color, and life.

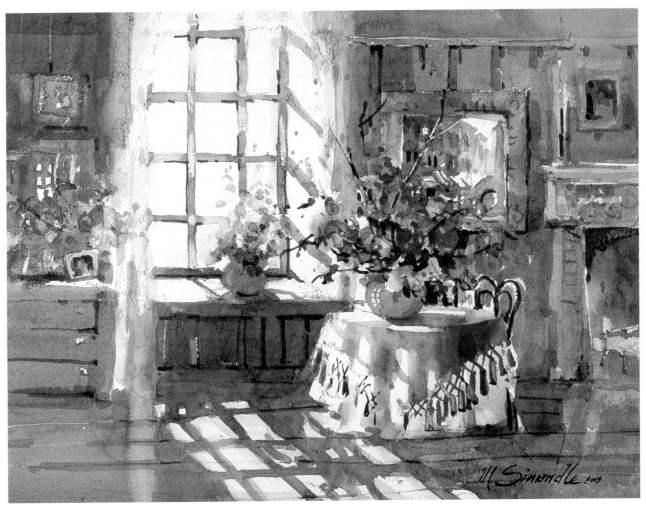

WINTER SUNLIGHT, 12" X 16"

Photograph Interiors for Reference

Photographing an appealing, yet shadowy interior will often be the only way you can save it for future reference. Here are some tips for getting the most useable photos:

1. Load your camera with fast film (ISO 400 or faster). The higher a film's ISO number, the faster, more sensitive to light it is.

2. Take a shot using available light, then take a second shot with a flash, to illuminate shadowed areas.

3. If your camera permits, make additional exposures of the room, without flash, at one F-stop, then two F-stops overexposed. F-stops represent different-sized lens aperture openings, so you want to make that opening larger to let in more light. The smaller the F-stop number, the bigger the lens aperture. Though this will cause highlights to burn out (overexpose), more shadow detail will be captured due to the increased exposure.

4. Plan to use the best parts of each of the above photos as reference material, but still rely heavily on memory and your imagination.

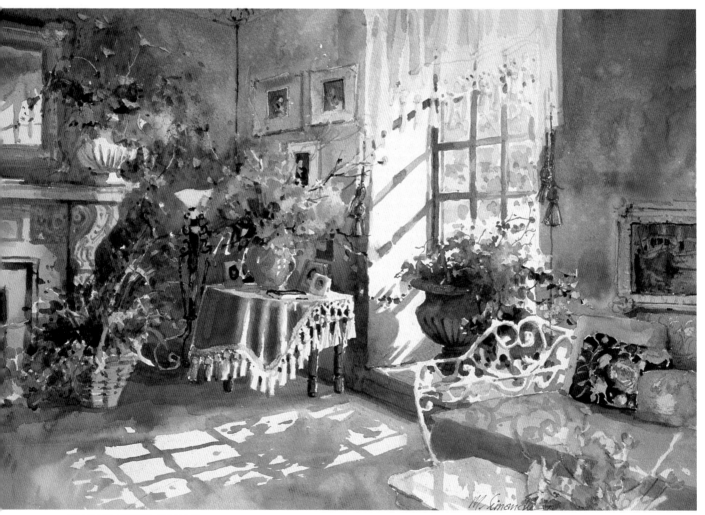

SUN-FILLED CORNER, 22″ X 30″

Paint Light-Filled Florals

Cheerful and decorative, floral still-life paintings are a celebration of life and color. That's probably why they're so popular. Just about everyone loves flowers, and though your painting may lack the fragrance of the real thing, it'll never wilt! Floral still-life arrangements provide the opportunity to bring the outdoors inside. They make colorful subjects that don't move, and you can work under lighting that won't change. Yet florals are just as challenging as any other subject. All the considerations of composition still apply. You must decide on the all-important point of interest, and emphasize it by manipulating a variety of shapes, values, detail and color to attract and please the eye. Foreground, middle ground and background must be handled to strengthen the effect.

Glowing With Light

This watercolor is a good example of how effective simplicity can be: The strong value and rich texture of the background make the flowers glow with light. Notice how the subtly scratched-in lines and negatively-painted spots of light fill the picture area with the arrangement.

PANSIES, 30" X 22"

Arrange a Floral Still Life

You don't have to paint exactly what you see, especially when painting a floral. Even the best floral setup gets somewhat simplified and rearranged on my paper. It's just part of the process. Nevertheless, starting with a poor subject puts you at an immediate disadvantage.

CREATE DOMINANT AND SUBORDINATE MASSES

When you arrange your floral, create dominant and subordinate masses. You don't want all your flowers to say "hello" at once. Group similar blossoms; overlap shapes to unify them; interrupt hard edges with overlapping elements. Try placing some flowers, petals or leaves on the table to create eye movement, and keep shapes pointing towards the point of interest.

USE LIGHTING AND BACKGROUNDS TO BRING OUT THE POINT OF INTEREST

As you work with lighting and backgrounds, save the strongest contrasts, brightest lights and purest colors for your point of interest. Shadows give your subject drama, depth and contrast. Dark backgrounds work best, with little or no definition, to bring out the brightness of the flowers. I tend to minimize, or entirely lose, the back edge of the setup table. It's generally an unnecessary distraction.

Too Much Going On
You don't know what to look at first. The reds compete for attention, sending your eye all over the place. Even the three pots compete, with their similar shapes and busy patterns. Avoid frequent repetitions of elements that are the same size, color or shape.

Top-Heavy Composition
All the interest here is massed at the top, like a lollipop on a stick, which presents composition problems.

A Good Arrangement
There's good contrast in the sizes of the elements here. Flower shapes break the line of the pot's rim. Flowers and leaves placed casually on the table lend an informal air and provide opportunities to move color around. When you arrive at a pleasing arrangement, study it from various angles.

***Moving to
the Right***
The setup still
works!

Low Viewpoint
This kind of angle
is quite dramatic!

High Viewpoint
A very high view-
point can also be
exciting.

Getting Up Close
Standing too far away is a common
mistake: Try coming in really close. It's
fine to let your arrangement run right
out of the picture area, because the
edges of your paper are part of the
composition too. Looking through a lit-
tle viewfinder (made by pushing the
film out of a 35mm slide holder, for
example) helps you compose your sub-
ject in this way.

Mix an Assortment of Greens

It seems as if greens are every watercolorist's bugaboo. Yet you really can't ignore them in florals and landscapes. So you buy tubes and tubes of greens that don't work. Why? Because using green straight from the tube makes all your greens look alike. Not very interesting. How do you create believable, appealing, exciting greens? Start by eliminating those tube greens from your palette. You don't need them! Fact is, you can easily mix loads of warm, cool, light, dark, bright or grayed greens with colors you already have on your palette. Look at the examples on these pages, then try some for yourself. You can create infinite variations with different proportions of each pair of colors. Blend them wet-in-wet, and see your washes come to life. You can even add a third color, but avoid mixing more than three.

Manganese Blue and Cadmium Yellow

Manganese Blue and Raw Sienna

Manganese Blue and Burnt Sienna

Manganese Blue and Cadmium Orange

Cobalt Blue and Raw Sienna

Cobalt Blue and Cadmium Orange

Cobalt Blue and Cadmium Yellow

French Ultramarine Blue and Raw Sienna

French Ultramarine Blue and Cadmium Orange

French Ultramarine Blue and Burnt Sienna

Antwerp Blue and Raw Sienna

Antwerp Blue and Burnt Sienna

Antwerp Blue and Cadmium Orange

Antwerp Blue and Cadmium Yellow

French Ultramarine Blue and Cadmium Yellow

Blooming With Light

Don't Just Copy

Use your subject as reference only. Never just copy what you see. Here's my floral setup. Wow! Busy, busy, busy! Everything hits the eye at once. Cropping the subject to eliminate the unnecessary is a good way to begin thinking about redesigning your subject; close one eye and look through a viewfinder (described on page 105) to block out all the surrounding material. If you're working from a photo, you can crop it with four strips of paper, then clip or tape them in place. As you paint, simplify what's left by omitting things you don't need, such as the right edge of the table. The background carnations and foreground roses add nothing. Leave them out! The lilies are separated and pointing in every direction. Group them! As with any subject, you should plan on moving elements around to create a variety of sizes, shapes and colors.

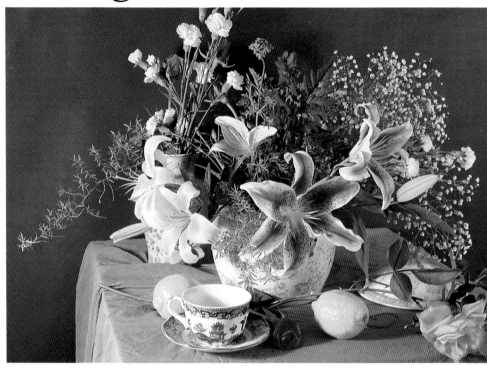

STEP 1 Create Order With Thumbnails and Value Sketches

The subject in the sketch at right is too small, too centered. If you're afraid to move in close, you often end up with a tiny subject floating in a large field, objects reduced to insignificant dots, and the background dominating the composition. That just doesn't work. If you're going to extremes, it's better to move in really close, framing a single blossom (or even just part of a blossom) to fill your paper. Develop your best idea with a slightly-more-detailed value sketch in just three values: light, medium, dark. Now you're ready for the big time.

CHOOSING A COMPOSITION

Thumbnail sketches help you decide how possible arrangements will fit on your paper. You get to know your subject better with each sketch. As you do your thumbnails, think of shapes and masses, not flowers. Try to create connected dark masses and connected light masses. Above all, keep your thumbnails simple!

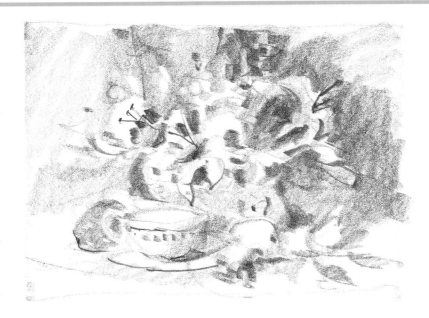

STEP DEMONSTRATION 2 Move Your Sketch to Watercolor Paper

Lay out your plan with a full-sized drawing on watercolor paper. Go for the big shapes first—massing, overlapping and fine tuning. Don't like the bowl?

Change it! Would a second bowl hiding behind it bring the first bowl forward? Add it now! Would fallen leaves and stems add interest? Sketch them in!

STEP 3 DEMONSTRATION Paint Large Masses First

As with a landscape, get your largest mass down first. Here it's the background, a middle-value gray-green wash of Manganese Blue and Raw Sienna, with a touch of Permanent Rose. Paint negatively around the floral shapes, varying the hues with warm (Cadmium Orange, Raw Sienna) and cool (Manganese Blue, Permanent Rose) colors each time you recharge your brush. Scratch into each still-moist wash to create the tangle of stems and leaves characteristic of an informal flower arrangement; repeat this scratching frequently as you progress.

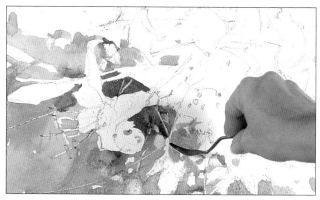

Leave plenty of whites for sparkle and light.

Begin here with a middle-value gray-green wash of Manganese Blue and Raw Sienna, with a touch of Permanent Rose.

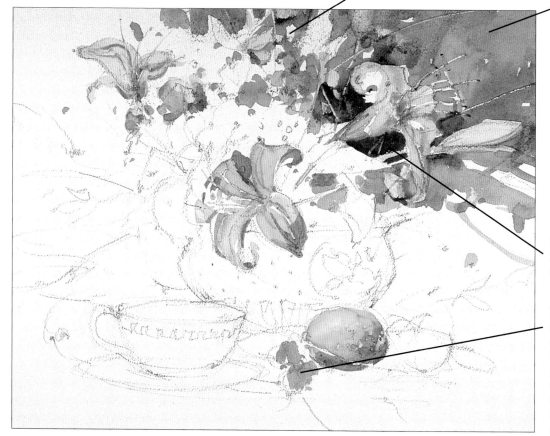

Negative shapes help develop positive shapes.

Soft violet (Permanent Rose and Manganese Blue) serves as complementary contrast against the adjacent yellow of the lemon. Move this violet around the painting.

STEP 4 Use a Variety of Greens

It's time to start dealing with varied greens. See pages 106-107 for my approach.

A CLOSER LOOK

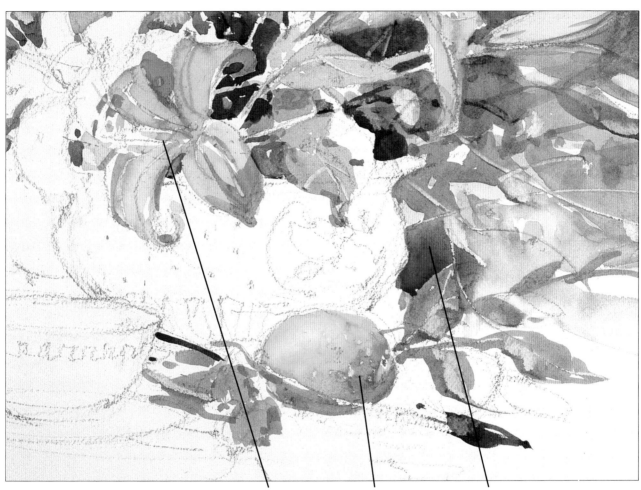

Begin local color of the point-of-interest flower with Permanent Rose and Cadmium Orange. When dry, shadow with both colors darkened with Burnt Sienna.

Squeegee and move moist paint around with your palette knife. Wash with Winsor Yellow, then drop in Cadmium Orange wet in wet.

Shade with Burnt Sienna. Make texture by stippling in tiny specks with your palette knife.

 # Focus on the Point Interest

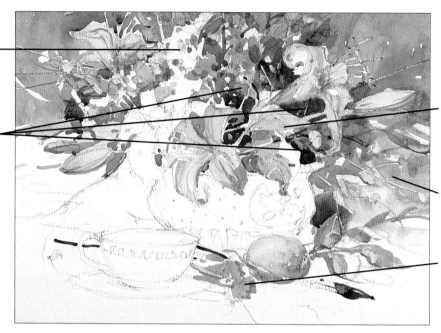

Consider not only the shape you're painting, but also the shape you're leaving behind.

Begin building darker values to frame the point of interest.

Place leaves where you want them, not where they happen to be.

Begin moving background down to meet foreground.

A mixture of Cobalt Blue and Permanent Rose forms a darker, softer violet.

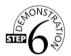 # Connect Shapes, Define Patterns

Begin connecting masses to unify the composition, squinting frequently to view the painting in terms of large shapes and patterns.

A darker wash of Alizarin Crimson and Burnt Sienna yields rich accents.

This lily is cooler and less bright because it is a secondary point of interest.

This lemon is darker and not as bright, because it isn't in the point of interest.

Warm the shadowed gray wash with Cadmium Orange to suggest light reflected from the lemon.

Glazing shadows over the china pattern softens its edges.

Make the background wash warmer as you bring it forward.

Add Finishing Details

Stand back and try to look at your painting objectively. Turn it upside down to see it solely as shapes and colors. Is it too busy? Glaze in color to tie fragmented areas together, as I've done with the background at top center. Do too many elements stand out at once? Glaze some darker to push them back; brighten the point of interest by surrounding it with darker shadow masses. Are values running together? Perhaps you need to separate them with value changes. An additional element, like the leaf at lower left that separates the cup handle from the lemon, may be just what the piece needs. Add final details like the china pattern, dark linear stems, and, of course, your signature!

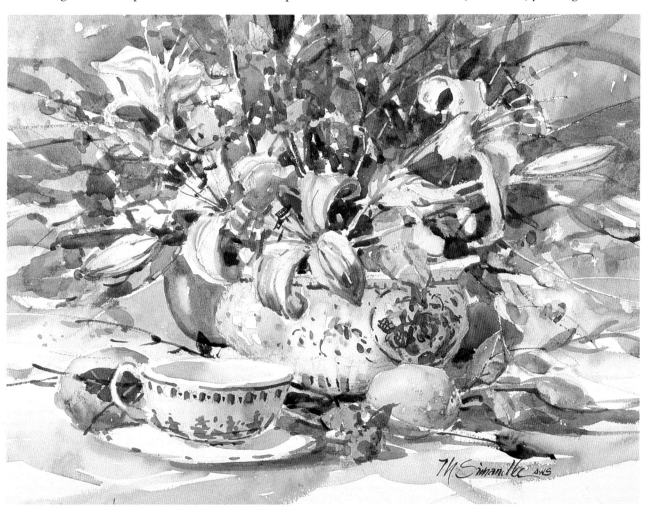

LILIES, LEMONS AND PORCELAIN, 14" X 18"

Paint Winter Scenes Indoors

Snow and watercolor go quite well together, the sparkle of one very much in tune with the brilliance of the other; and without a doubt, painting on location is the best way to learn. Even the finest camera and film can't capture the colors that glow in every shadow, nor the subtle light that bounces from every surface. Yet, I'm the first to admit that it's not much fun standing ankle-deep in snow trying to complete a painting before my water (and my toes) freeze! These days, winter is a pleasure I enjoy best from a distance. While I still do an occasional winter painting on location (see *Lake Mary*, below), the majority of my snow paintings are based on photos from my files, backed by years of observation and experience.

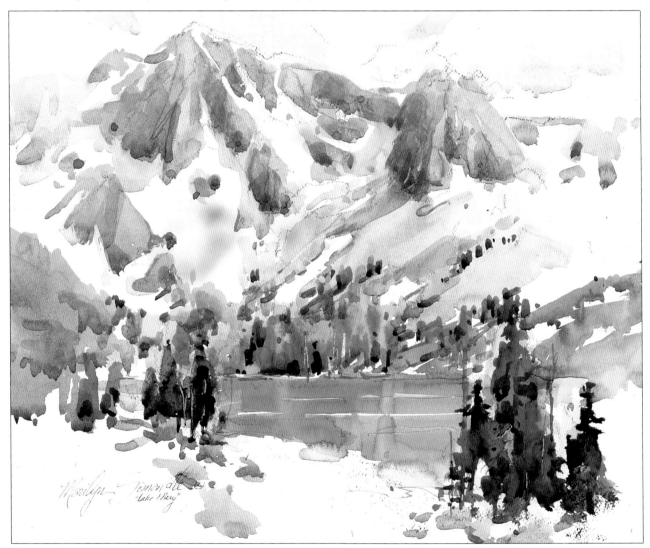

LAKE MARY, 12″ X 16″

Quick Winter Piece

I offer this little painting as proof that I still paint on location, even in winter! I did it with palette and paints spread out on the tailgate of our truck in a wind-blown, finger-freezing, foot-stomping half hour. My Cadmium Orange actually froze while I was working! On the plus side though, I find that I often do my best work when I push myself to finish quickly!! Brrr!

A Sparkling Winter Scene

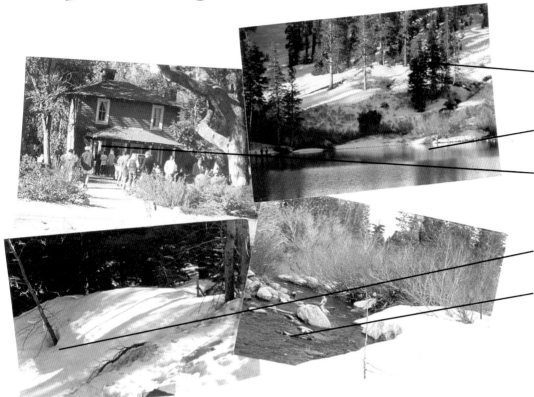

I love the tree shapes against the snowy hill . . .

. . . and the reflections in the stream.

This old house with its wonderful shadows will make a nice point of interest.

Great trees and shadows!

Let's use this brook flowing through the snow.

Assemble the Ingredients

Using several scenes from my files, I've decided that the point of interest for my next painting will be that solid old house (which, you'll notice, was photographed in summer). The winter photos will be invaluable for shadows, form, value and inspiration. This is the way I work in my studio, often with ten or more photos for reference. Rarely is a single snapshot exactly what I want. Your painting should be *as you want it to look*.

KNOWING AND INTERPRETING WINTER

It's still a great help to have experienced and painted winter from direct observation. I've been there, come to know winter and its subtleties, and over the years I've interpreted it in countless paintings.

STEP 1 Create a Composition

Should you place the house at left or at right? Where to place the stream? Shadows are very important. Where should they fall and what kind of connected shadow pattern will work best? Begin by blocking out big shapes and bold values. A value sketch will help define composition and establish the value pattern.

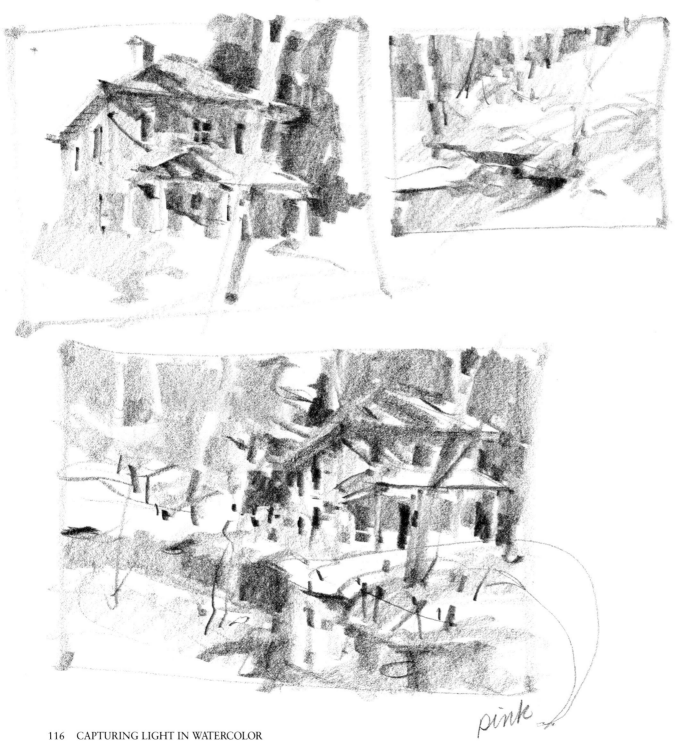

pink

STEP 2 Put It on Watercolor Paper

Though I'm known as an artist who paints loosely, I like to work from a precise, accurate drawing. That's not a contradiction. A careful drawing establishes the composition, frees you from thinking about objects and allows you to concentrate on shapes.

Sketch standing up if you can, your 6B pencil held flat against the paper to get your whole body (not just fingers and wrist) into the motion of sketching. Draw the house first because it is the major shape and point of interest. Next comes the stream.

STEP 3 Create the Biggest Shapes First

A CLOSER LOOK

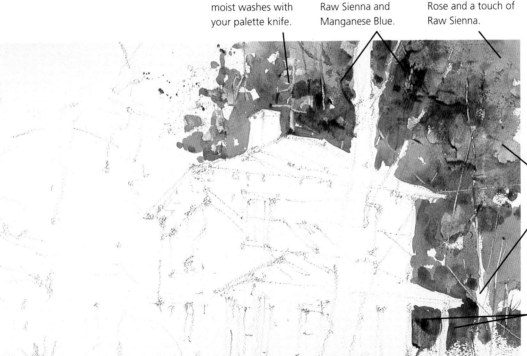

Scratch and smear moist washes with your palette knife.

Raw Sienna and Manganese Blue.

Begin here: Manganese Blue with Permanent Rose and a touch of Raw Sienna.

Blend warm and cool, dark and light, to keep each wash colorful.

Leave more whites for sparkle and light than you think you'll need!

When painting "behind" something, be sure to carry colors from one side to the other.

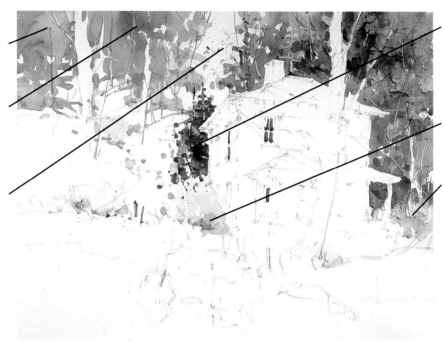

Cooler, grayer, lighter values (a mixture of Cobalt Violet and Permanent Rose) recede.

A mixture of Cobalt Blue and Raw Sienna makes a soft green.

This area offers a visual escape from the point of interest.

Establish darkest value with a mixture of Antwerp Blue and Burnt Sienna. Use Sap Green for lighter greens.

Drop in a touch of Cadmium Red Medium while wet.

Wintery shrubs are a mixture of Permanent Rose and Cadmium Orange.

STEP 4 Define Foreground Colors

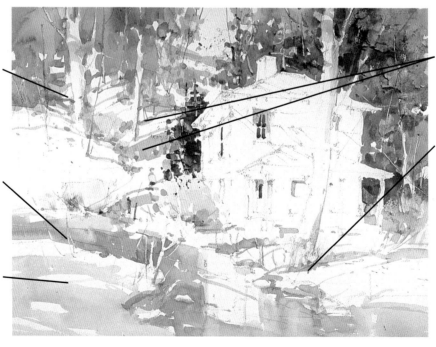

Background shadows and trees are close in value range.

Begin the stream with a mixture of Antwerp Blue, Raw Sienna and Permanent Rose. Scratch lines as you go.

Foreground snow shadows are warmer than the stream: Manganese Blue, Permanent Rose and Cadmium Orange over a very light glaze of Cadmium Orange.

Know your light source: Be sure to keep shadows going in the same direction.

Darker snow shadows are lit by the sky: Cobalt Blue and Permanent Rose.

 # Develop the Point of Interest

Remember that the brightest colors, strongest contrasts and the most detail should all be in the center of interest.

A CLOSER LOOK

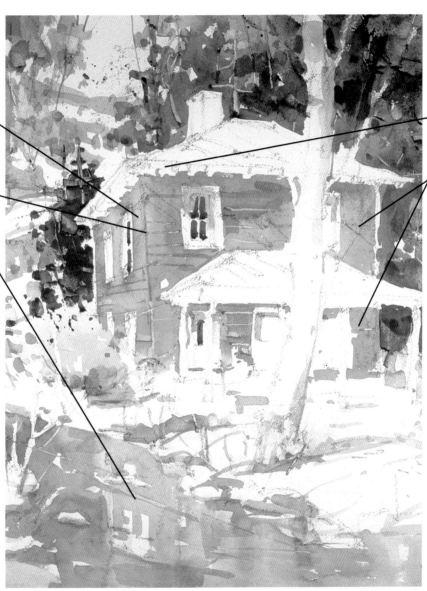

Begin with the local color: Cadmium Scarlet and Cadmium Orange.

Scratch lines for siding.

Don't forget reflections, and how moving water breaks them up.

Make edges interesting.

Keep varying colors in your washes as you go.

STEP DEMONSTRATION 6 Finish Blocking in Forms

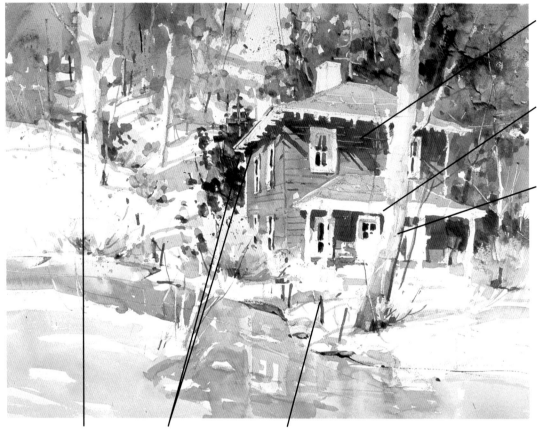

Glaze shadows with a mixture of Burnt Sienna, Alizarin Crimson and a touch of Antwerp Blue.

Make good use of "lost and found" edges which blend into other shapes, then reappear.

The tree trunk is dark against light background, light against dark.

Dark elements here help balance the point of interest.

Connecting these darks helps the eye move from tree to house.

Snow shadow colors (Cobalt Blue and Permanent Rose) also move around the painting.

LESS IS MORE

One of the hardest things to know is at what point a painting is finished. The impulse is to keep adding detail long after we should have stopped. More paintings are lost at this finishing stage than at any other. My husband Ted often says that every artist should be two people: one who paints, and another who hits the painter over the head and tells him to stop.

Watercolor works best when it implies rather than describes. Look at that tree in front of *The House by the Stream*, and how little it takes to make it work. Like the poet who uses very few words to say volumes, the painterly painter uses very few brushstrokes, regarding each painting as a conversation in which the viewer will actively participate to fill in the details.

Adding too much detail, the artist ends up (boringly) dominating that conversation. That's why it's important not to fuss with small areas in your painting. The noted English painter Sir Joshua Reynolds (1723-1792) once pointed out that "painting blades of grass is a sign of idleness, not industry." Amen to that! Get in there, get it down, and leave it alone!

STEP 7 Add Finishing Touches

Now it's time to adjust values, lay some accents of pure Permanent Rose and Cadmium Orange into the point of interest and add just a few calligraphic lines to describe siding, roof, tree branches and grasses. Decisions are based on what's to be brought forward or moved back, what should draw the eye and what should not.

Finally, stand back and evaluate your painting. Have you achieved harmony and variety in large and small shapes? In light and dark values? Are the brightest colors, strongest value contrasts and finest detail centered in the point of interest? If you're not quite sure, turn your painting upside-down and look at it. You'll see it as an unfamiliar abstract, and the patterns of shapes and values will be more visible.

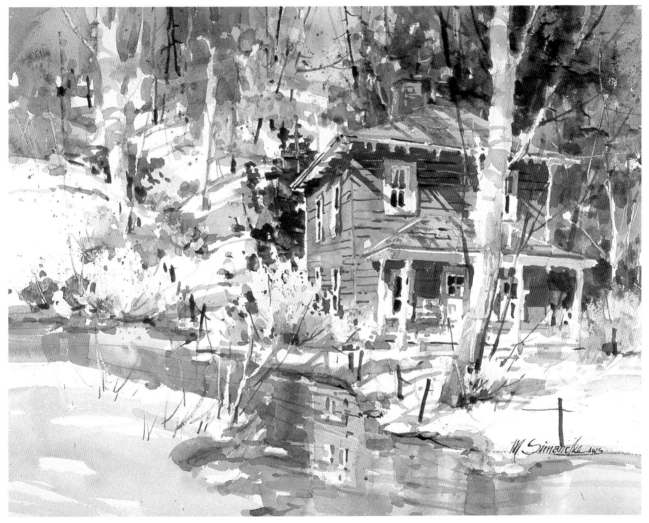

THE HOUSE BY THE STREAM, 16" X 20"

My Favorite Books

Out-of-print editions may be found at your library, through a book-finding service, or in a used bookstore.

Brommer, Gerald F. *Transparent Watercolor: Ideas and Techniques*. Davis Publications: Worcester, MA, 1973. Out of print. An easy-to-follow instruction book by an acknowledged master teacher.

Carlson, John F. *Carlson's Guide to Landscape Painting*. Sterling Publishing Co., Inc.: New York, NY, 1929. Reprinted in paperback by Dover Publishing: Mineola, NY, 1973. Reprinted by Peter Smith: Magnolia, MA, 1984. A classic that every landscape painter should own, this book contains just about everything you need to know about landscape painting.

Edwards, Betty. *Drawing on the Right Side of the Brain*. J. P. Tarcher, Inc.: Los Angeles, CA, 1979. Revised edition issued 1989. Quite possibly the best book ever written for getting you excited about . . . and achieving success with . . . drawing. Edwards shows you how to bypass your analytical left brain and tap into your creative right brain.

Henri, Robert. *The Art Spirit*. Harper and Row: New York, NY, 1923. Reprinted several times in paperback. The essential, inspirational beliefs and theories of one of America's finest teachers and artists. This book might well be considered the artist's Bible.

Parramon, J. M. *Composition*. H. P. Books: Tucson, AZ, 1981. Out of print. A neat little paperback that lays out the basics of composition in an easy-to-follow manner.

Payne, Edgar. *Composition of Outdoor Painting*. Edgar Payne: 1941. Reprinted by DeRu's Fine Art Books: Belle Flower, CA. A must-have for the classical outdoor painter. As fresh and relevant today as when it was first published.

Reid, Charles. *Painting What You Want To See*. Watson-Guptill Publications: New York, NY, 1983. Out of print. There are some great projects in this book, plus good examples about the use of values and contour drawing.

SANTA YNEZ VALLEY, 8" X 16"

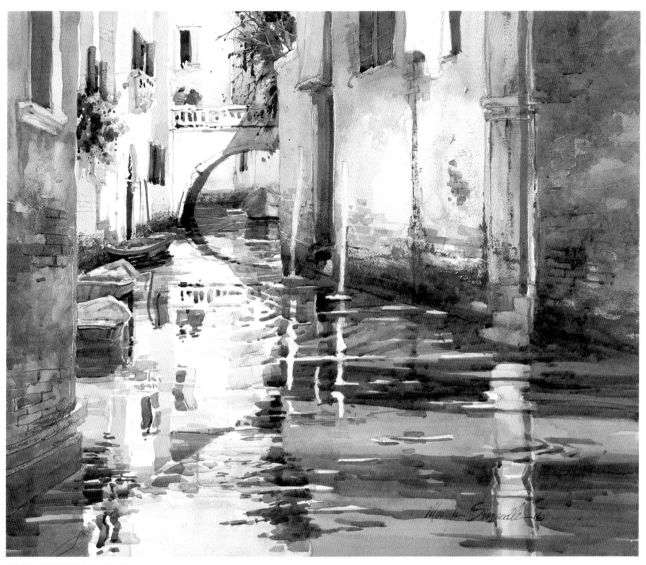

VENICE REFLECTIONS, 20" X 26"

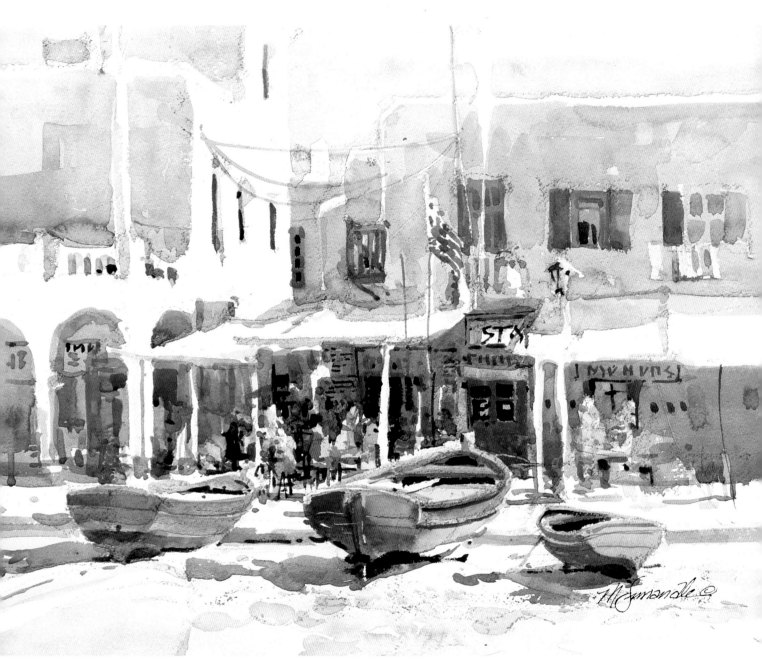

MYKONOS, 12" X 16"

PLATE PATTERNS, 22" X 30"

INDEX